MIND-FORG'D MANACLES

WILLIAM BLAKE AND SLAVERY

MIND-FORG'D MANACLES

WILLIAM BLAKE AND SLAVERY

DAVID BINDMAN

With an essay by
DARRYL PINCKNEY

With 66 illustrations

Published on the occasion of the exhibition
Mind-forg'd Manacles: William Blake and Slavery,
a Hayward Gallery Touring / British Museum Partnership UK Exhibition

Exhibition Tour:
Ferens Art Gallery, Hull: 7 April–20 May 2007
Burrell Collection, Glasgow: 3 November–6 January 2008
Whitworth Art Gallery, Manchester: 26 January–6 April 2008

Exhibition curated by David Bindman
Exhibition organised by Isabel Finch and Roger Malbert

Art Publisher: Charlotte Troy
Publishing Co-ordinator: Oriana Fox
Sales Manager: Deborah Power
Catalogue designed by Kerr / Noble
Printed in the UK by BAS Printers on recycled stock

Published by The Hayward Gallery Publishing, Southbank Centre,
London SE1 8XX, UK, southbankcentre.co.uk

Distributed in the United States of America through D.A.P. / Distributed Art Publishers
155 Sixth Avenue, 2nd Floor, New York, N.Y. 10013
Tel: (212) 627-1999; Fax: (212) 627-9484; artbook.com

Distributed outside America by Cornerhouse Publications, 70 Oxford Street,
Manchester M1 5NH, tel. +44 (0)161 200 1503; fax. +44 (0)161 200 1504;
cornerhouse.org/books

Cover Image: William Blake
Urizen in Chains from *The First Book of Urizen*, Copy D, 1794
© Copyright the Trustees of The British Museum

CONTENTS

FOREWORD

Mind-forg'd Manacles: William Blake and Slavery is the first exhibition and publication devoted to the theme of slavery in William Blake's art and writing. Coinciding with the 250th anniversary of Blake's birth and the bicentenary of the abolition of the British Transatlantic slave trade, it has a dual significance. William Blake was fervently opposed to slavery and contemptuous of the forces in Britain that tried to prolong it. He was made aware in detail of the cruelty of the slave trade when commissioned to produce engravings illustrating the narrative of Captain Stedman, a mercenary soldier in the Dutch West Indies (six of these engravings, taken from Stedman's own drawings, are included here). But for Blake slavery was also a mental state. To have limited perceptions, to pursue materialistic ends, to follow conventional religion or science was to be enslaved and to be imprisoned with 'mind-forg'd manacles' of one's own making. In Blake's art, many of his most dramatic and complex images show a confrontation between the forces of repression and those seeking freedom.

For *Mind-forg'd Manacles*, curator and Blake scholar David Bindman has brought together fifty watercolours, engravings and plates from Blake's illuminated books. These are all drawn from the collection of the British Museum which has the most complete representation of Blake's work anywhere in the world. They range across his career from the *Songs of Innocence* to the late Prophetic books, *Milton, a Poem* and *Jerusalem*. Blake's radical vision has inspired generations of readers, but his Prophetic writings are often esoteric and inaccessible to the non-specialist. David Bindman's elucidation of the theme of slavery running through Blake's thought and imagery is therefore especially welcome, and his essay and commentaries on each image provide an essential key to their interpretation.

Complementing this close reading of Blake's highly personal symbolic imagery, the novelist and literary critic Darryl Pinckney reflects on the real experience of slavery in the late eighteenth and early nineteenth centuries, from the perspective of Olaudah Equiano, a former slave and near-contemporary of Blake's, who was the first black person to write his autobiography in English. In his compelling essay, Pinckney recounts the story of Equiano's adventures at sea and on land in England and the West Indies, and reminds us that there were black communities in Great Britain in the eighteenth century, long before the Windrush generation.

In addition to Blake's own images, *Mind-forg'd Manacles* includes several other prints from the period: the famous diagramatic print showing the conditions aboard the slave ship, the *Brookes* (a widely distributed image for the abolitionist cause that was given to every member of Parliament); the idealised or sentimental depictions of the African slave as pitiable victim or grateful supplicant; and the caricatures that would have been seen by Blake in the windows of London's print shops.

The contradictions of cruelty and pity that Blake understood so profoundly can be felt in the ambiguous atmosphere surrounding the bicentenary today, where commemoration of the suffering inflicted on millions is blended with celebration of the abolition – with perhaps a more than a hint of self-congratulation at British liberality. Yet for many in this country whose ancestors were forcibly transported across the Atlantic, the legacy of slavery and the slave trade remains a live issue.

ACKNOWLEDGEMENTS

Mind-Forg'd Manacles: William Blake and Slavery was conceived and curated by David Bindman, and we thank him for generously sharing his vast knowledge of Blake's poetry and art and for energetically realising this project in time to coincide with the 250th anniversary of his birth.

This exhibition is the latest in an ongoing series of collaborations between the Hayward Gallery/Southbank Centre and the British Museum. It represents a particular strand in the Hayward Touring Programme which, although mainly focusing on modern and contemporary art, occasionally reaches further back into art history when there is a pressing reason for doing so. William Blake's unique appeal to so many creative thinkers and artists is, we hope, sufficient justification. Darryl Pinckney's fine essay has added an important dimension to this book, vividly reminding us of the historical realities of slavery.

With one exception, all the works in the exhibition are on loan from the Department of Prints and Drawings at the British Museum. We are grateful to the Board of Trustees at the British Museum and to Director Neil Macgregor for agreeing to lend the works for this Hayward Touring exhibition. We are particularly indebted to Frances Carey, Head of National Programmes at the British Museum, for her enthusiastic commitment and encouragement. We also thank Antony Griffiths, Keeper of the Department of Prints and Drawings, and his colleagues, Sheila O'Connell, who has provided vital curatorial liaison on all aspects of the exhibition, Janice Reading, Angela Roche and Charles Collinson.

For the loan of the Slave Medallion, we thank the Trustees of the Wedgwood Museum, Stoke-on-Trent, as well as Director, Gaye Blake Roberts and Curator, Sharon Gater.

The success of the exhibition depends on the whole-hearted collaboration of the curators at the three galleries where it will be shown, and we thank Christine Brady of the Ferens Art Gallery in Hull, Muriel King and Vivien Hamilton of the Burrell Collection, Glasgow, and David Morris and Mary Griffiths of the Whitworth Art Gallery, Manchester, for supporting this Hayward Touring project.

At The Hayward, the following colleagues have been closely involved in the exhibition and publication: Helen Luckett, Natasha Smith and Sepake Angiama from Public Programmes; Charlotte Troy, Oriana Fox and Deborah Power from Publishing; Samantha Cox and Alison Maun from the Registrar's Department; Mark King, Steve Cook, Geock Brown and Steve Bullas from the technical team; Sarah Davies and Gilly Fox from Press and Helen Faulkner and Kathryn Havelock from Marketing.

Finally we would like to thank Frith Kerr and Ryan Ras from Kerr/Noble for their originality and care in designing this publication.

RALPH RUGOFF
Director, Hayward Gallery, Southbank Centre

ROGER MALBERT
Senior Curator, Hayward Gallery Touring, Southbank Centre

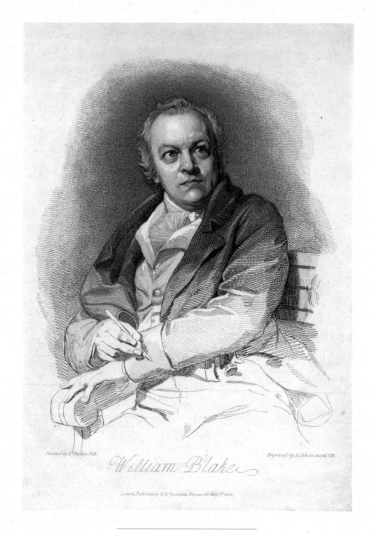

William Blake

Painted by T. Phillips R.A. Engraved by L. Schiavonetti V.A.

London, Published by R.H. Cromek, Newman St. May 1st 1808.

LUIGI SCHIAVONETTI,

after THOMAS PHILLIPS

William Blake, Frontispiece to *Robert
Blair, The Grave* (1813 edition), 1808
Etching
372 x 262mm | © BM 1862, 1108.25

MIND-FORG'D MANACLES
WILLIAM BLAKE
AND SLAVERY

DAVID BINDMAN

Until late in the eighteenth century the British slave trade, which was based on the transportation of millions of Africans from Africa to North America and the West Indies to work under compulsion on sugar and tobacco plantations, had a role in national prosperity that was taken for granted, as it was in other slave-trading countries. Public disquiet against its cruelty and injustice, and doubts about the legality of slavery in Britain began to arise in the early 1770s, and by the late 1780s serious attempts were made to outlaw the trade in Parliament. The campaign led by former slaves like Olaudah Equiano, and concerned citizens like Granville Sharp, Thomas Clarkson and William Wilberforce converted public opinion into opposition to the slave trade, but there was still strong resistance on the part of the slave owners who remained powerful in Parliament, and were able to use the 1789 French Revolution's opposition to slavery in the French colonies as an argument that the emancipation of slaves would be a threat to the social order in Britain. An act against the slave trade was finally achieved in 1807, though plantation slavery was not abolished in British colonies until 1838.

William Blake was born in 1757; thus he grew up in the period of the abolition campaign, and was greatly affected by it. He was strongly opposed to slavery, as were most of his fellow-artists, including Sir Joshua Reynolds, the President of the Royal Academy, but in Blake's case it played an unusually important part in his work, particularly in the 1790s, and there are signs of responses in his work to the 1807 act. His engagement with slavery derived from his vivid if indirect experience of its cruelties in the Dutch colony of Surinam, through his work on the mercenary soldier John Gabriel Stedman's volume *Narrative of a five years expedition against* p.34 *the Revolted Negroes of Surinam...* from the years 1772 to 1777, which was published in 1796 with many engravings by him after Stedman's now lost drawings. Blake also mixed in the well-known anti-slavery circle of the publisher Joseph Johnson, who published the Stedman volumes, and brought out the works of the feminist pioneer Mary Wollstonecraft, one of which Blake illustrated.

Living in London and working in the world of commercial engraving as a way of supporting his activities as an imaginative artist, Blake must have been aware of current images of slavery produced mainly by those sympathetic to the

abolitionist cause, such as the most incendiary of all anti-slave trade prints, the widely distributed **p.30** woodcut of the slaving ship *Brookes*, first published in December 1788, with slaves lined up for transportation on every inch of the decks[1]. He must also have seen and sympathised with John Raphael Smith's mezzotints after George Morland's sentimental but well-intentioned **p.31** paintings of *The Slave Trade* and *African Hospitality*, which appeared in 1791. Living in London he could have seen caricatures like Isaac Cruikshanks's exposure of the notoriously cruel Cap- **p.32** tain Kimber in *The Abolition of the Slave Trade* of 1792, Gillray's shocking scene of the cruelty of an overseer in the West Indies dropping a **p.32** slave in a vat of sugar, in *Barbarities in the West Indies* of 1791, or the same artist's cynical view **p.33** of Wilberforce and the abolitionists in *Philanthropic Consolations after the loss of the Slave Bill* of 1796.

The humour of such caricatures contrasts with Blake's engravings for Stedman, some of which picture in harrowing detail the horrendous punishments inflicted on African slaves for transgressions and resistance in Surinam. The engravings illustrating Stedman's text show slavery as a concrete and commercial practice that inflicted unimaginable suffering on its victims. Stedman, however, was not in principle opposed to the system of slavery, despite his admiration and sympathy for many of the slaves he encountered, but, like many at the time, he was opposed to their ill-treatment and to the rapacity of the slave owners[II]. He was in Surinam as part of a Dutch military force recruited to put down a slave revolt. In the course of this campaign he witnessed the punishments meted out to slaves, which he on occasions tried ineffectually to prevent. He also gave a highly romanticised account of falling in love with and going through a form of marriage to a young mulatto

girl Joanna, whom he was ultimately unable to save from enslavement.

Blake seems to have had a part in the long drawn-out production of the volume, and to have become friendly with Stedman, dining with him on the latter's visits to London from Devon. Blake was responsible for three of the most harrowing images in the volume, but most of the 16 either signed by or attributed to him, from the total of 80 plates in the volume, are of more peaceful scenes. Though Blake does not dwell fully in his three illustrations of punishments on the physical horrors described by Stedman, they have nonetheless a great deal of pathos and drama. Blake was also responsible for engraving from Stedman's design the final allegorical plate, *Europe supported by Africa & America*, **p.38** which shows the three continents embracing each other as sisters, or as the Three Graces. The two darker sisters submissively support the white figure of Europe, despite Stedman's claim that 'we only differ in colour, but are certainly all created by the same Hand'.

The slavery represented by Stedman and in Blake's illustrations was physical and their representation was based on observation, but the *idea* of slavery was also much used in the eighteenth century in ordinary conversation, in political rhetoric and in literature, as it was before and still is. One could talk, for example, of someone being a slave to fashion, or, like the American colonists and Blake himself, claim that British taxation of the American colonies without representation was a form of slavery. An unhappy marriage could be seen as enslavement to conventional morality, and false religious belief could be treated as a form of mental slavery from which the mind needed to be liberated. Blake used the word mainly in this last sense, claiming that those who believed in materialism or practiced a materialistic religion, among

12

which he placed the Catholic and the Anglican Churches, were like slaves obedient to an oppressive master, or like prisoners confined within a small space. This self-inflicted state of mental slavery was contrasted with the exultant freedom of true worship and artistic creation, and the opposition between the two states is a central theme of Blake's work in both painting and poetry. As he put it through the words of Los, the eternal poet, in his epic poem *Jerusalem*: 'I must Create a System. Or be enslav'd by another Mans / I will not Reason & Compare: my business is to Create'.

Blake was not unusual in his time in using slavery as a metaphor and figure of speech, but his use of the word is exceptional in being tied to the physical reality of slavery. Hence the prevalence in his imagery of the 1790s of manacles and chains as a reflection of the enslavement of narrow, materialistic minds, and the contrasting images of the breaking of chains in the awareness of the power of the spirit. Imagery of enslavement and release is at the heart of his Illuminated books and prophecies, which tell, in text and design combined, the story of human beings' mental experience in the material world and their hopes of redemption in the world beyond.

THE LITTLE BLACK BOY

Blake's first considered reference to the condition of Africa, however, predates his involvement with Stedman, and is involved with the issue of skin colour. The poem *The Little Black Boy* in *Songs of Innocence* of 1789 is in the voice of an African boy meditating on his blackness, looking forward to his liberation along with a 'little English boy', 'When I from black and he from white cloud free'. The poem begins with the African boy's unredeemed state in Africa:

My mother bore me in the southern wild,

And I am black, but O! my soul is white;
White as an angel is the English child,
But I am black, as if bereav'd of light.

At the end of the poem the Little Black Boy achieves redemption in throwing off his blackness and joining the white boy, who is also a prisoner of his skin colour, and is now 'from white cloud free', at the knee of Christ [III]. At first reading the poem suggests that Blake has simply taken over uncritically the conventional trope of the African darkened by the sun as a metaphor of his ignorance, with a white soul that will emerge through faith. This trope has early Christian origins, and it is found on the well-known tombstone in Henbury Churchyard near Bristol, of 'Scipio Africanus Negro Servant to the Right Honourable Charles William Earl of Suffolk and Brandon' who died in 1720, aged eighteen. It begins:

I who was Born a PAGAN and a SLAVE
Now Sweetly Sleep a Christian in
 my Grave
What tho' my hue was dark my
 Savior's sight
Shall Change this darkness into
 radiant light [IV]

Though the meaning of Blake's poem has been the subject of much argument, it is probable, given that Blake was a fervent political and religious radical, that it was meant ironically, as a satire of the expectation by abolitionists that liberated slaves would willingly continue to serve their liberators out of gratitude. This is perhaps hinted at in the second plate in the relative position of the boys: the black boy is subordinate to the white boy, who himself adopts a position of servility toward Christ. Such a position with hands together in prayer usually has a negative meaning in Blake's imagery [V]. It also echoes the recently produced and hugely popular medallion manufactured by the great potter Josiah Wedg-

13

wood, captioned 'Am I not a Man and Brother?' in which a liberated slave boy, still bearing his chains, offers himself in supplication to his liberator. But this enormously influential image, as Hugh Honour has pointed out [VI], expresses the equivocation of some of the early abolitionist campaigners towards Africans; they were to be freed from slavery but were assumed still to be in a child-like state, deserving of kindness but unqualified for equality. Blake's radicalism would surely have made him suspicious of such ideas.

p.43 The Wedgwood medallion instantly became enormously popular, and was reproduced in many different forms; as an ornament to be worn, on medals, printed works, money tokens and tobacco boxes. It also had its effect on the sculptor John Flaxman, whose drawing of *Liberty freeing a Slave* shows a freed black expressing gratitude to the allegorical figure of liberty. The origins of the motif is clearly to be found in the little black boys, themselves deriving from *putti* in Italian paintings, which were used at the time on shop signs, tobacco papers and trade cards, where they are often associated with the pleasures of tobacco, or the delights of life enjoyed by plantation owners in the slave colonies.

MENTAL SLAVERY AND THE CHAINING OF DESIRE

The phrase 'mind-forg'd manacles' occurs in the poem in *Songs of Experience* entitled *London*. It expresses the miseries of urban life and the way in which they are associated with mental slavery:

In every cry of every Man.

In every Infants cry of fear.

In every voice; in every ban.

The mind-forg'd manacles I hear.

The enslaved mind is both a cause and consequence of the material life of the city, which disallows, according to Blake, any redemptive life

of the spirit. The poem *London* needs to be seen p.54 in the context of the *Songs of Experience* written in 1794, five years later than *Songs of Innocence*. *Songs of Innocence* represent the 'unfallen' state of childhood that precedes the inevitable and necessary descent into earthly life or experience before true redemption can be achieved. In some cases poems in *Innocence* have their 'fallen' counterpart in *Experience*, as in *The Ecchoing* p.56 *Green* and *The Garden of Love*. *The Ecchoing Green* p.58 tells of children in their state of innocence playing on the village green, while *The Garden of Love* in *Experience* describes the imposition of mental restraints on two children by 'Priests in black gowns... making their rounds, And binding with briars, my joys and desires'.

The Illuminated book *Visions of the Daughters of Albion* also shows the crushing of innocence by religious and political power, but this time in the institution of marriage. Blake argues that marriage enforced by conventional (male) assumptions can enslave the women of Britain who long for liberation, symbolised by the new American republic across the Atlantic: 'Enslav'd, the Daughters of Albion weep; a trembling lamentation / Upon their mountains; in their valleys, sighs towards America'. The motif of enslavement is carried through the whole volume in the story of three people who are locked together in frustration. In the title page, the heroine Oothoon who seeks liberty is tied through rape to Bromion, who boasts of ownership of 'the harlot' Oothoon in the same terms as his slaves: 'stampt with my signet are the swarthy children of the sun; / They are obedient, they resist not, they obey the scourge'. Yet slave owners are themselves mental slaves, and Bromion is depicted in the frontispiece to the book manacled to a rock by the seashore and to Oothoon, while Theotormon whom she loves bears his lonely agony apart from them, an inef-

fectual figure perhaps based on Stedman, who failed to liberate the slave girl he married. Theotormon's pain invokes in him 'The voice of slaves beneath the sun, and children bought with money'; among the text is a small illustration which seems to show a black slave in a state of collapse beneath a blue sky, his pick put aside. It is Blake's only direct representation in his Illuminated books of physical slavery, yet it functions as a metaphor of Theotormon's impotent state of despair.

The idea of marriage as potential enslavement in the *Visions of the Daughters of Albion* has long been understood as due to the influence of Blake's acquaintanceship with Mary Wollstonecraft, who was also working for the radical publisher Joseph Johnson at this time. But it is also worth noting that Blake's engravings for Stedman's *Surinam* are mostly dated 1792 and 1793, the very time he would have been working on the *Visions*. It is surely not coincidental that the figure of Bromion is not only explicitly identified as a slave owner, but acts like the cruellest and most dissipated of the plantation owners described by Stedman. The reference to the stamping of the slaves with a signet or mark of ownership also derives from Stedman's description of the branding of slaves offered for sale.

In Blake's Prophetic books of 1793–94 the enslavement of humanity is attributed to Urizen, the presiding deity of the material world, who represents the domination of rationality unmitigated by the spirit, and all the powers that enslave man's soul and body. *The First Book of Urizen*, 1794, one of Blake's densest and most opaque works, tells the story of the creation of mankind but through the myth of Los, the eternal artist, who gives form to Urizen but becomes enthralled by his creation. Los is led to chain to a rock his son Orc, who represents the repressed desire of mankind for the liberation of the spirit. Urizen's forms of repression are directed towards the human mind. In the title **p.68** page he writes and perhaps also draws in large books, seated before the Tablets of the Law with their prohibitions, and in plate 4 he holds open **p.70** an enormous book with vague landscape forms that express the baleful power of mystery over the human mind.

Much of the action of *Book of Urizen* tells of Los's intense struggle to give form to Urizen so that mankind can understand the true nature of the world. Those who mentally enslave others are themselves slaves, and this is brought out in plate 20, a full page illustration of Urizen with **p.76** manacles around his ankles and wrists, and in the last plate of the book where he is imprisoned in a net of his own devising. *The First Book of Urizen* is a book filled with magnificent and tragic images that tell of the origins of man's present plight under the oppression of materialism. The same story is told in the Colour Print of 1795, *The House of Death*, which shows a **p.80** Urizen-like blind figure presiding over a dreadful scene of human alienation.

But Los also suffers jealousy of his child Orc, symbolised by a tightening girdle around his chest, the Chain of Jealousy. Los is depicted in one plate as a Vulcan-like figure, looking jeal- **p.74** ously at Orc's embrace of his own partner Enitharmon. It is jealousy – to Blake the besetting sin of artists – that makes Los complicit with Urizen and leads to him removing his chain and using it to tie the infant Orc to a rock for the centuries of the dominance of the Catholic and Anglican churches.

THROWING OFF THE CHAINS
REVOLUTION

Orc breaks free of his chains in the moment of the American Revolution, as described in the Prophetic book *America: A Prophecy*, like *Visions*

of the Daughters of Albion dated 1793, and equally dependent on images of slavery. It tells in allegorical terms and apocalyptic language of the American Revolution, embodied in the adolescent figure of Orc, whose breaking of the manacles and chains that bind him to a rock signals the uprising of the human and Christian spirit after many centuries of the oppression of Church and State. In the Preludium to the poem p.84 Orc is shown manacled to a rock, in a position, as has been frequently noted, that is almost certainly derived from the plate by Blake after Stedman in the Surinam book, of the grim scene of p.40 *The Execution of Breaking on the Rack*. Orc breaks free and rises up in the Prophecy plate, still with his broken chains attached. His previous state represents the enslavement by the British of the Americans on the eve of revolution. Evoking the miseries of plantation slavery Blake puts the following words in the mouth of George Washington:

> A heavy iron chain
> Descends link by link from Albions
> cliffs across the sea to bind
> Brothers & sons of America, till our
> faces pale and yellow;
> Heads deprest, voices weak,
> eyes downcast hands work-bruis'd,
> Feet bleeding on the sultry sands,
> and the furrows of the whip
> Descend to generations that in future
> times forget.

Liberation and revolution are represented by the p.88 figure of Orc rising up to challenge the deity of the old order, the white-bearded Urizen, but the moment of release from political and mental slavery is pictured with consummate sensitivity p.86 in plate 8. A naked seated figure looks up wonderingly into the air after his liberation from the grave, while the text suggests the exultation of the moment:

> The grave is burst, the spices shed,
> the linen wrapped up;
> The bones of death, the cov'ring·clay,
> the sinews shrunk & dry'd.
> Reviving shake. Inspiring move,
> breathing! Awakening!
> Spring like redeemed captives when
> their bonds & bars are burst;
> Let the slave grinding at the mill,
> run out into the field:
> Let him look up into the heavens
> & laugh in the bright air;

In the poem all is action, movement and exultation but the seated figure expresses the wonderment and tentativeness of the actual moment of liberation, in which the slave is still attached to the earth from which he has just been freed.

America: A Prophecy, unlike *The Book of* p.92 *Urizen*, contains intimations of an as yet unfulfilled redemption. Orc confronts Urizen and threatens his domination of mankind, but Urizen succeeds by the last plate in damping down Orc's fires, until they burst out again in France in 1789. In so far as the poem reflects the events in France of 1792–3 this ending perhaps represents a moment of doubt about the ultimate triumph of Orc. Blake did, however, make one image that completely expresses the exultation of redemption in this period, the separate colour print of 1794–6, entitled *The Dance of Albion* (British Museum but not exhibited here), part of a collection called 'A Large Book of Designs' of samples of his unique new method of colour printing. In what is one of Blake's most exhilarating designs the archetypal figure of Albion celebrates with extended arms a vision of liberation from the body that contrasts strongly with the self-enclosed figures in a state of mental captivity that predominate in his imagery of the 1790s. In a later line engraved version of c.1803–10, Blake has added a caption in the

Huntington Library imression, that associates Albion's exultation with his release from the slavery of material life: 'Albion rose from where he laboured at the Mill with Slaves / Giving himself for the Nations he danc'd the dance of Eternal Death'. The reference to a mill as the location of slave labour suggests that slavery in Blake's mind has been domesticated from the colonies and is here applied to labourers in workshops and factories. Albion, as both everyman and the British nation, becomes one with Orc in seeking personal and national redemption from the slavery of material life in a world beyond the material one, in an image that anticipates Blake's great national myth *Jerusalem* of 1804–20. It also looks forward to the other great theme of his later years, the practice of the arts as a form of celebratory prayer.

THE WORLD AS PRISON, DEATH AS LIBERATION

By the mid-1790s Blake's imaginative designs had gained a certain reputation particularly among artists associated with the Royal Academy. This reputation led to an unusual commission to provide a series of watercolour illustrations for engravings to go into a new and splendid edition of Edward Young's long poem *Night Thoughts*, the most popular of the mid-eighteenth-century 'Graveyard' poems. It consists of a lengthy meditation on the meaning of death and the case for Christianity as offering hope for a life beyond. Its Anglican piety would not have been particularly sympathetic to Blake; nonetheless he embarked with enthusiasm on a total of 537 watercolours, now in the British Museum. In the event only 43 were engraved from the first four of the nine 'Nights' that comprise Young's text.

Blake characteristically emphasised his own themes in his illustrations, and there are many images in which he has taken lines from Young's text and elaborated them into images of mental captivity or liberation, perhaps influenced by reports of imprisonment of large numbers of people in France under the Revolution in 1793 and beyond. References to slavery still occur but they become less attached to the horrors of plantation slavery described by Stedman. In page 12 of the first 'Night' he has taken the lines: p.100

O how self-fettered was my
 groveling soul?
How like a Worm,
 was I wrapt round and round
In silken thought,
 which reptile fancy spun
Till darken'd Reason lay quite
 clouded over

Reason is represented by a Urizen-like old man with a worm-like body, vainly looking in mirror, while the whole scene is girded round with a chain, expressing the narcissism of reason without the spirit.

In page 18 a catalogue of the miseries of p.102 life, pain and death is expressed by a slave manacled to the oar of a boat 'hammered to the galling Oar for life'. In page 30 of *Night 3* death is invoked as giving 'the Soul wings to mount above the Spheres' while the human mind is 'By Tyrant *Life* dethron'd imprison'd, pain'd'. Blake p.104 has represented this thought of life on earth as a prison by a manacled man in a gaol giving way to despair. In page 31 of *Night 5* the idea that p.106 those who reject spirituality for wordly pleasure 'Sink into Slaves; and sell for present Hire', to 'the Prince who sways this Nether world' or Satan. They will then seek to escape their enslavement but will be, as Blake shows in his illustration, guarded by '*Horrors* doubled to defend the Pass', the demons who express their own mental captivity. In *Night 7* page 40 the fear p.108 of death of the non-believer is represent-

ed by captivity in a dragon's den. Those who seek solace in pleasure, the 'boasters of liberty fast bound in Chains!', are represented by a naked figure in manacles which, like those worn by a plantation slave, allow him only restricted movement.

p.112 The title page to *Night 8* shows the powers of the world represented as heads of the Great Beast of Revelation, ridden by the Whore of Babylon. Cardinal and Pope, Judge and Warrior, these are the true enslavers of the minds of p.114 humanity. In *Night 9* page 15 we see Satan now himself manacled as the apocalyptic vision of the end of the world is fulfilled, and towards the end p.116 of the poem, in the vision of redemption, a soul is shown floating free of the prison of the body beneath. In two unpublished designs for illustra-p.118 tions to Robert Blair's *The Grave*, a similar kind of poem to Young's *Night Thoughts*, Blake expresses the idea of death as liberation from the captivity of the body. In an alternative design for the title-page a male figure on the right has, like p.120 Orc in *America*, broken the chains that hold him to the earth while his son next to him is still captive. In the beautiful design for the Dedication to the Queen the soul with a key in her hand, leaving the body beneath, rises up to the golden Door of Death 'that Mortal Eyes cannot behold'.

NATIONAL LIBERATION ALBION

Blake's anthem 'And did those feet in ancient time' though popularly known as 'Blake's Jerusalem' is actually from the Prophetic book p.124 *Milton, a Poem*, dated 1804, and not from *Jerusalem*. It was preceded on the same page by a ringing attack on the classical tradition in the form of 'The Stolen and perverted Writings of Homer and Ovid; of Plato and Cicero, which all Men ought to contemn', by 'the silly Greek & Latin slaves of the sword', on behalf of 'the Sublime of

the Bible'. Mental enslavement is now seen at this late phase of his career as the dominance of classical culture, which stands for war and materialism opposed to the Christian spirit. *Milton, a Poem* is an attempt to redeem what was in Blake's eyes the flawed but essential inheritance of the great seventeenth-century English poet John Milton who comes to earth to merge with his follower William Blake as deliverer of the nation from Urizen and his tablets of the Law, illustrated on plate 15. p.126

The poem also introduces for the first time a national myth embodied in the figure of the everyman Albion. He becomes the central figure of the final epic *Jerusalem*, the summation in 100 plates of Blake's myth of humanity. *Jerusalem*, dated 1804 on the title page but not completed until the 1820s, is filled with powerful images of figures fighting against their mental limitations. It is not easy to summarise the dense imagery of *Jerusalem*, but it tells the story of Albion in his divided state, and the role of the arts represented by Los in the hoped-for unification of Albion himself and his uniting with his female 'emanation' Jerusalem, and ultimately with all living creatures. Los's fight is against the materialist philosophy that rules Britain, represented in plate six by the Spectre, an interior force seeking to dissuade Los from his heroic efforts to forge an image of the reality of the nation's mental captivity. Los is enslaved by the Spectre but frees himself to provide for the divided Albion a way to the spirit.

The people of Britain, the Sons and Daughters of Albion, are, like the Jews in the prophecies of Isaiah and Ezekiel in the Old Testament, divided from each other in the pursuit of materialism. In plate 25 three of the Daughters, like p.132 the Three Fates, spin out the distressed Albion's mortal coil, while in plate 37 a figure, usually p.136 identified as Albion, is crouched over in ultim-

ate despair, in the power of the Spectre of false belief, hence his mental captivity is self-inflicted. The association of society's despair and mental slavery is made clear in plate 51 where three of the presiding powers of the world are shown in self-absorbed agony. They are identified by Blake in a proof of the plate as Vala, Hyle and Skofeld. Vala is Blake's name for the female personification of nature, Hyle's name is a play on Blake's unfortunate patron the poet William Hayley, and Skofeld refers to the soldier responsible for Blake's arrest as a spy, who was called Schofield. Blake was hostile to the nature worship associated with Wordsworth and the Romantic poets on the grounds that it meant submission to the material world. Hyle like his near namesake Hayley represents the arts as superficial pleasure and idle comfort, while Skofeld represents war and is, as Morton Paley has put it, 'wearing his mind-forg'd manacles'.

Jerusalem ends in the last few plates with a prophetic vision of Albion, guided by Los, throwing off his allegiance to false gods. This redemption is foreshadowed in plate 76 where Albion is shown worshipping Christ on the Tree of Life not submissively but exultantly. The final scenes of the poem represent the rising of humanity from mental captivity, division and death as in plate 95 Albion rises naked, leaving the earth behind. In plate 97 Los calls Jerusalem to awake and unite with Albion in the final vision of the unity of all living creatures in the apocalyptic embrace of an old man, perhaps the redeemed Jehovah with a young woman with streaming hair, probably Jerusalem.

In fact the vision of redemption in *Jerusalem* is but a dream; for Blake Britain in the early nineteenth century was still a country mentally enslaved by the material powers of nature, war and false art, with only a few artists keeping alive a vision of a better world. References to actual slavery in the poem are rare but there is one passage on plate 45 that suggests an oblique response to the Abolition Act of 1807. It is in the voice of 'Bath' who represents an anxious liberal view of Albion's plight:

> Africa in sleep
> Rose in the night of Beulah,
> and bound down the Sun & Moon
> His friends cut his strong chains,
> & overwhelmed his dark
> Machines in Fury & destruction,
> and the Man reviving repented
> He wept before his wrathful brethren,
> thankful & considerate
> For their well-timed wrath.

Though this passage is somewhat opaque, Blake seems to attribute the success of abolition to the efforts of the slaves themselves, assisted by friends who release them from their chains. But Bath argues that Albion cannot be saved by such an act of liberation but only one of mercy, for 'Albion's sleep is not like Africa's'; he needs more than political action to achieve his own liberation.

There is a more unequivocal reference to slavery at about the time of the 1807 act in Blake's tempera painting of *The Spiritual Form of Nelson guiding Leviathan* (Tate Britain). It shows the naked and heroic figure of Nelson guiding the immense sea serpent Leviathan, which holds in its coils agonised figures, presumably representing the naval enemies of Britain. Beneath Nelson in the foreground, prostrate on the sea shore, is the body of a black African with manacles on his wrists. The painting, along with its companion *The Spiritual Form of Pitt Guiding Behemoth* (Tate Britain) of the Prime Minister guiding the forces of destruction on land, were intended, as modelli for gigantic paintings to go in public places, to show the acts of Nelson and Pitt in the light of Biblical history as a reminder

p.136
p.138
p.140
p.142
p.21

of the vanity of worldly power. The African is not caught up in the coils of Leviathan but is in an equivocal position; on the one hand he lies on the shore of freedom presumably after rescue from the ghastly sea-borne trade, but he is also exhausted and still bears his manacles. The suggestion is perhaps that in Albion's present plight of self-division and the dominance of war no true liberty is possible for him, for the abolition of the slave trade did not mean the abolition of slavery, nor the imposition of equality for former slaves within Britain.

Blake's responses to slavery are then somewhat apart from and more radical than the more 'respectable' abolitionists of his time, like Granville Sharp and Thomas Clarkson. He did not see the enslavement of Africans as an aberration from or an affront to British values, but inherent in Britain's materialist and warlike character, and its confinement to a narrow view of the world. The physical enslavement of Africans was a consequence of the British elite's own mental enslavement, that only true artists and poets, like himself, could see clearly and warn of its consequences.

FOOTNOTES

I. Schama, Simon, *Rough Crossings: Britain, the Slaves and the American Revolution*, Ecco, London, 2006, 246.

II. The Prices argue that Johnson's copy editor eliminated and distorted many passages written by Stedman that he regarded as excessively critical of slave owning and the debauched conduct of slave owners. (Richard and Sally Price eds., *John Gabriel Stedman, Narrative of a Five Year Expedition against the Revolted Negroes of Surinam*, Johns Hopkins University Press, Baltimore, 1988, lxi–lxiv.

III. For a recent discussion see David Bindman, 'Blake's Vision of Slavery Revisited', *Huntington Library Quarterly*, vol. 58, nos. 3 and 4 (1997), 97–106.

IV. Jones, Pip and Rita Youseph, *The Black Population of Bristol in the eighteenth century*, Bristol, 1994, 10.

V. Intriguingly Blake varied the colouring of different copies of the second plate showing the redeemed black boy behind the white boy at Christ's knee. In early copies the black boy has achieved the whiteness of redemption and is represented as the same colour as the white boy. In some later printings of the work, however, Blake has deliberately made the black boy's body dark by applying a grey wash.

VI. Honour, Hugh, *The Image of the Black in Western Art*, vol. 4 part 1, Harvard University Press, Cambridge, 1989, p.62.

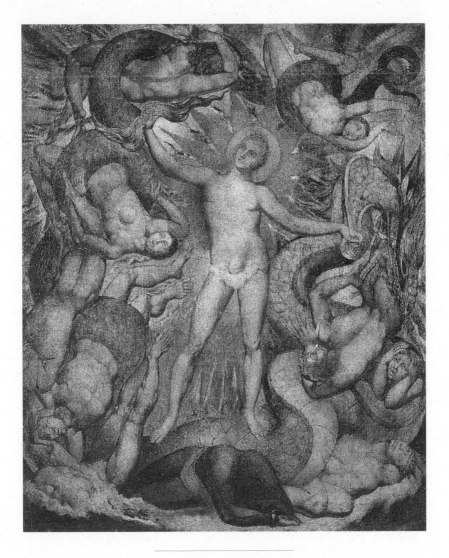

WILLIAM BLAKE
The Spiritual form of Nelson Guiding Leviathan c.1805–9
Tempera on canvas
762 x 625mm | Tate Collection N03006/103
Courtesy Tate Britain

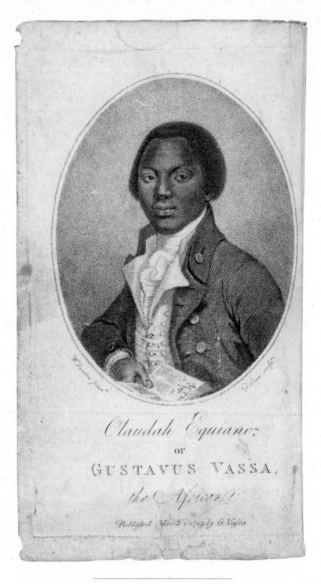

W. DENTON; D. ORME,
Olaudah Equiano, Frontispiece to *The Interesting Narrative of the Life of Olaudah Equiano, or Gustavus Vassa, the African,* 1789

'IN MY ORIGINAL FREE AFRICAN STATE'

DARRYL PINCKNEY

In *The History of the Rise, Progress, and Accomplishment of the Abolition of the African Slave-Trade by the British Parliament*, published in 1808, Thomas Clarkson numbers Elizabeth Tudor among the forerunners of anti-slavery advocates. He cites her concern when Sir John Hawkins returned to England in 1562 that he may have used unjustifiable means to procure African persons, that he may have carried them off without their consent. Clarkson did not know that 34 years later the defender of the faith was urging in an open letter to her lord mayor and sundry sheriffs that some 'blackmores' recently arrived be sent forth from the land, because there were already too many of them in England, and they had no understanding of Christ or the Gospels. In 1601, the queen issued a proclamation, describing herself as highly discontented by the great numbers of 'negars' and 'Blackamoores' who had crept into the realm.[1] The weary woman's proclamation had little effect, just as the back-to-Africa resettlement schemes of the late eighteenth and early twentieth centuries were failures for the most part, including the Sierra Leone project with which Clarkson was associated. Where are the descendants of London's seventeenth-century black residents, of Bristol's and Liverpool's eigteenth-century black populations? They have faded into the family histories of their white neighbours. The black presence in Great Britain did not begin with *Windrush*.

Clarkson celebrates his 'necessary forerunners' in the abolitionist cause, the monarchs, captains, vicars, poets, philosophers, bishops, pamphleteers, former slave owners, and Quakers who spoke out before 1787. That year he and 11 other 'indefatigable patrons of Africa,' businessmen and tradesmen, formed themselves into a committee to investigate and publish evidence about the barbarity of the slave trade. In bestowing commendation upon them, he points out, he was not bestowing it upon himself, because he was often absent from their deliberations. He is proud of their exertions, noting how often they met and for how long, and that they distributed 'twenty-six thousand five hundred and twenty six reports, accounts of debates in parliament, and other small papers', and 'no less than fifty-one thousand four hundred and thirty-two pamphlets, or books'. For seven years, he kept up a correspondence 'with four hundred persons with my own hand', and travelled 35 thousand miles in search of evidence,

23

such as interviewing a lone witness of a slave massacre that had taken place aboard ship. Often he undertook such journeys at night. Meanwhile, his mind was vexed, harassed, afflicted, *wounded* – his words – by the testimony about the cruel trade, by the scenes mass kidnap led him to imagine. His nervous system was nearly shattered, he says.

Clarkson had been converted to the abolitionist cause when he won a competition at Cambridge in 1785 for the best essay in Latin on the question of whether enslaving others against their will was ever justified. He says that until he wrote his essay he knew nothing about the subject. He was deeply affected by the antislavery works of the Reverend James Ramsay and the American Quaker, Anthony Benezet. The story of abolition became, for him, one of great Englishmen in strenuous debate, of Pitt, Fox, or Wilberforce rising at late hours to address the House. The cause was lost, abandoned, then taken up again; and the eventual defeat of the slave lobby was momentous. The victory belonged to the Christian faithful, for it was as important to improve the moral condition of his countrymen, as it was to relieve the sufferings of their fellow creatures in Africa, Clarkson said. He'd given his best years to this labour, he who had no trouble believing in the intelligence of Ignatius Sancho. Yet black people have no voice in his *History*. They are the oppressed, the 'injured Africans'. And in his tender roster of those who exhausted themselves on behalf of 'the cause', he never once mentions any of the black abolitionists of his acquaintance.

Clarkson knew Olaudah Equiano, who in 1788 presented Queen Charlotte with a petition on behalf of his African brethren, as Benezet had done. James Ramsay was a friend Clarkson and Equiano had in common, and Equiano took part in the war of words over slavery that erupted in press and pamphlet after 1787. He would become even more widely known when he published his autobiography, *The Interesting Narrative of the Life of Olaudah Equiano, or Gustavus Vasa, the African, Written by Himself*, in 1789. Equiano died in 1797, when the crusade against the slave trade had stalled. The French abolitionist, the Abbé Henri Grégoire, lamented the fact that Equiano did not live to see the righteous cause triumphant. Equiano had conceived of his book as an argument on the anti-slavery side, but his autobiography crosses a few genres. It is a slave narrative, a captivity tale, a travelogue, as well as a conversion tale, and it made the former slave's fortune, going through several editions in his lifetime. Clarkson wrote his history of abolition as a contest between white men; Equiano wrote his history of himself as his battle for a free life among white men.

Everything is in the title. Equiano was the first black person to write his autobiography in English, without the assistance of an amanuensis. He has a plain, forceful style; his prose carries the sound of the self-taught man, the lover of Milton, the student of Scripture. That he wrote the work himself, without mediators, is of the utmost importance. Knowledge of God was once thought to be the chief distinction between man and animal, but during the Enlightenment possession of a written language came to be seen as proof of one's individual humanity, and evidence of a civilization's high development. The book of poems Phillis Wheatley published in 1772 contains in its preface a list of 16 distinguished signatories, including the lieutenant governor of Massachusetts, attesting that the work was her own, because so many white people refused to believe that black people were capable of literacy, never mind the composition of verse.[11] Significantly, Equiano has a list of distinguished subscribers, but he asks no

one to vouch for his achievement. He, a black man in control of his own story, is importantly placed, at the beginnings of black literature in the West.

A part of Equiano's appeal is that he is a link to the severed past. He has memories of Africa, sketchy though they are, where he says he was born an 'Eboe', or Ibo, in the kingdom of Benin, or what is now Nigeria, in 1745. His father was an elder, or chief. He came from a family of seven siblings, he says, of whom he was the youngest boy. His little sister was the only daughter. 'The head of the family usually eats alone; his wives and slaves have also their separate tables. Before we taste food, we always wash our hands: indeed our cleanliness on all occasions is extreme.' They were monotheists. 'We practiced circumcision like the Jews, and made offerings and feasts on that occasion in the same manner as they did.' Equiano remembers an idyll, of course, a land of abundance, of vast quantities of vegetables, tobacco, goats, oils, perfumes, cotton. There are visits to markets with his mother and houses with red walls. Everyone tills the land; everyone, including women, fights when attacked. The wedding feasts, dances, musical instruments, drums, the simple dress of muslin or calico, usually dyed blue – he recalls ceremonial life more than he does family life, all of which will contrast sharply with the miseries of chattel slavery in the New World.

One day when the adults were in the fields, two men and one woman got over the walls of Equiano's house and abducted him and his sister. They were tied, gagged, put in sacks, and eventually separated. He was 11 years old. He changed masters often and was carried off some distance in a short matter of time. He was reunited with his sister, only to be torn from her again. He says he always found someone who could understand his language, until he came to the coast, some six or seven months after he had been kidnapped. He'd had cocoa nuts and sugar cane for the first time and had seen his first large river. Throughout his narrative, Equiano has the ability to convey what it was like to be in terror, yet to marvel at new sights: the ocean, flying fish, clocks, horses, snow, walruses, a painted portrait. And he can relate what it was like to see large ships and white people for the first time; what it was like to see a multitude of black people chained together in dejection and sorrow. He will make the point more than once that slavery in African societies prepared no one for the horrors to come. Here is the witness of the Middle Passage:

I was soon put down under the decks,
and there I received such a salutation in
my nostrils as I had never experienced
in my life; so that with the loathsomeness
of the stench, and crying together,
I became so sick and low that I was
not able to eat, nor had I the least
desire to taste any thing. I now wished
for the last friend, Death, to relieve me;
but soon, to my grief, two of the white
men offered me eatables; and, on my
refusing to eat, one of them held me
fast by the hands, and laid me across,
I think, the windlass, and tied my feet,
while the other flogged me severely.[III]

Equiano says he thought he'd got into a world of bad spirits.

After landing at Barbados, he was sold and taken to Virginia. Providence brought him to the attention of Michael Pascal, a lieutenant in the royal navy then acting as captain of a merchant ship. Pascal purchased Equiano and renamed him – he'd had two or three names since being kidnapped – Gustavus Vasa, after the Swedish king who had freed his country from Denmark.

Thus began Equiano's long career at sea and it was his life as a valued sailor and steward that made him consider himself favoured by heaven among his countrymen. He was not condemned to a short and brutal life, toiling on a plantation in the merciless sun. Life at sea was hard, but he was treated neither as a slave nor a prisoner and this life afforded him chances that he would not have had otherwise. He would see Naples, Cadiz, Smyrna, New York, and the shores of Honduras. He learned navigation. Equiano's education began as soon as he set sail with Pascal, thanks to one Richard Baker, a youth three years his senior who became the first friend of his profoundly altered state. Equiano offers what Henry Louis Gates, Jr. famously identified as the 'trope of the Talking Book' that black writers of autobiographies in the eighteenth century shared as a convention or a metaphor for illiteracy, exclusion.[IV]

> I had often seen my master and
> Dick employed in reading; and I had
> a great curiosity to talk to the books,
> as I thought they did; and so to learn
> how all things had a beginning: for
> that purpose I have often taken up
> a book, and have talked to it, and
> then put my ears to it, when alone,
> in the hopes it would answer me;
> and I have been very much concerned
> when I found it remained silent.

On his first voyage to England, white people seemed full of wisdom and magic. Soon he came to regard whites as people superior in power to his countrymen, but not spirits. White people, he notes, did not sell one another, as black people did.

Equiano is not a political thinker or even a reformist in this work, though he is indignant at the way he was treated and outraged by the injustices he has witnessed over the years. His autobiography is largely a tale of shipping out and miraculously surviving one disaster at sea after another. It is a tale of swindles, of trying to make white people pay him when he does a little business on his own selling fruit or turkeys. To stand up for himself usually called forth the repressive violence of the whites he had dealings with. A black man could not testify against a white man in the West Indies or the US. Everywhere, he keeps a sharp eye on his money. He never forgets a farthing of his transactions, and he always knew his worth, rather like Babu in Melville's story, but he neglects to say that the Revolutionary War is in progress during one of his passages to North America. Earlier, he had hungered to see action and he describes the fear of being under fire as he brought powder to the ship's cannon during the Seven Years War. He was soon seasoned in warfare at sea. Equiano had a talent for reliving his experience in the immediacy of his language. Everything he felt he is feeling again when he writes. His descriptions of, say, a vessel exploding or a ship running aground are vivid.

He spent more time than he wanted sailing among the islands of the West Indies, being ill-used by whites who had no legal or moral obligations to the blacks with whom they had dealings. Equiano is not unaware of his tendency to want to turn his masters into substitute fathers, a desperate inclination that more often than not ended in betrayal and hurt. He was able to accumulate some capital through his trading on voyages and after disappointments and setbacks, he purchased his freedom in 1766. 'These words of my master were like a voice from heaven to me; in an instant all my trepidation was turned into unutterable bliss; and I most reverently bowed myself with gratitude, unable to express my feelings, but by the overflowing of my eyes, and a heart replete with thanks to

God.' Once free, he carried on managing the cargo of others in the West Indies, from a sense of duty to his employers, though he longed to get away to England.

What the sea gave Equiano was England, and a way to be an Englishman without suffering too often from the precarious existence of the free black in England. Once or twice he worked for a hairdresser in London, but he earned more at sea and the life was in his blood. On one voyage he took a cargo of slaves to Georgia from the West Indies; on another he was urged to stay on Montserrat and to acquire slaves of his own. He tired of the dishonesty of white people in the West Indies and returned to London, where he worked with Dr. Charles Irving on his experiments to desalinate sea water. In 1773, he, along with the young Horatio Nelson, was a member of Constantine John Phipps' expedition to the Arctic Circle. The journey was so harrowing that Equiano experienced an access of piety afterwards. He had heard the Methodist evangelist, George Whitefield, in Philadelphia some years before. 'I saw this pious man exhorting the people with the greatest fervour and earnestness, and sweating as much as ever I did while in slavery on Montserrat beach.' He was tormented by the question of whether salvation was available only to an elect or whether deeds on earth could influence the fate of one's soul. He castigated himself for keeping only eight of the ten commandments, and it must have been a nuisance to have on board a black Christian who complained to the point of tears about the blasphemy and swearing of a ship's crew. However, one afternoon while he was meditating on the fourth chapter of the Acts, the Lord broke in upon his soul with bright beams of heavenly light, and he saw clearly, with the eye of faith, the crucified Christ.

As a conversion tale, Equiano's *Narrative* doesn't have the 'Paradise Lost / Paradise Regained' problem of sin being more interesting to read about than purity, because the hell of slavery was still all around him. In 1774, he tried hard to rescue a shipmate who had been kidnapped in London and taken to St. Kitts by his former master. He enlisted the aid of Granville Sharp, but the attorney Equiano hired absconded with his money and he received word in the meantime that his friend had died under terrible circumstances. Equiano thought of giving up England for Turkey, but sailed for Jamaica, with the thought of converting as many souls there as he could. He was seized and nearly sold off himself on this voyage and when he returned to London in 1777, he was determined to give up the seafaring life. In 1779, he asked the bishop of London to send him as a missionary to Africa, but to no avail. By 1786, he was again on the ocean, heading toward Philadelphia, one of his favourite cities. On coming back to London, he became involved in the Sierra Leone company that Clarkson's brother was head of. Equiano planned to oppose the slave traders in Africa with every means at his disposal, but the scheme to rid London of poor blacks, many of whom were slaves who had fled behind British lines during the American revolution, was spoiled by corruption, requiring Equiano to defend his honour vigorously. Most of the black colonists died within three years. Had Equiano gone with them as he planned it is likely that he, too, would have perished — and before he wrote his autobiography.

The 1791 edition of his *Narrative* ends with Equiano pleased that there are Dutch, German, and American editions of his work. We know how much longer he has, but he doesn't, a married man of some property cautioning us to look for the hand of God in the minutest occurrence, though he never reconciles himself to slavery by

saying that it at least gave him knowledge of the Gospels. A recent work, *Equiano the African: Biography of a Self-Made Man*, by Vincent Carretta advances the theory that Equiano was not born in Africa at all, that baptismal and naval records show that he came from South Carolina, and that he invented his African birth in order to make himself more representative or authoritative in the anti-slavery debate.[V] This in no way diminishes Carretta's admiration for Equiano, whom he interprets as a reclaimer of the African past, a bold creator of his own identity. However, to accept Carretta's argument requires us to see Equiano also as a master salesman, a performer, a trickster figure, when what has been so attractive about him has been his guilelessness, his candour. Equiano's grief at the memory of young Richard Baker's death puts one in mind of the 'little black boy' in the lines of Blake. He refused to run away when he had the chance; he refused to steal himself. Equiano wanted to restore himself to his 'original free African state' through his own talents and energies. Before the Mansfield decision of 1772, which ruled that no slave could be forcibly removed from Britain and resold into slavery, even the formerly enslaved lived under threat of kidnap. Then, too, the mariner's slavery that Equiano bought himself out of was very different from the nineteenth-century slave system in America that the runaway Frederick Douglass describes in his first autobiography, the greatest of the slave narratives. A reluctance to accept Carretta's theory might also have to do with the moral purity often demanded of black heroes. After all, Equiano wasn't asking for the freedom to be ordinary. Perhaps after he got his freedom he decided that, like so many newcomers to the capital, he, an 'obscure individual, and [a] stranger, too', enjoyed the liberty of the city, the licence to be modern and to make himself over,

confident that God would approve his higher purpose. His voice remains true, full of suffering, wonder, courage, and the determination to put down African roots in the British realm.

FOOTNOTES

I. Peter Fryer, *Staying Power: The History of Black People in Britain*, Pluto Press, 1984.

II. Ottobah Cugoano's *Thoughts and Sentiments on the Evil and Wicked Traffic of the Slavery and Commerce of Human Species* was only just published in 1787. A *Narrative of the Lord's Wonderful Dealings with John Marrant, a Black* was published in 1785, in New York. A *Narrative of the most remarkable particulars in the life of James Albert Ukawsaw Gronniosaw, an African prince, as related by himself*, published in 1770, is a brief oral history taken down by someone else. Phillis Wheatley's *Poems on Various Subjjects, Religious and Moral*, published in 1772, is the first book to be published in English by a writer of African descent. The black writers who enjoyed the patronage of George Whitefield and the Countess of Huntingdon were not necessarily active in the abolitionist cause.

III. See Henry Louis Gates Jr.'s *The Signifying Monkey: A Theory of African-American Literary Criticism* published by Oxford University Press in 1988.

IV. Gates Jr., Henry Louis, *The Trial of Phillis Wheatley*, Oxford University Press, Oxford, 2003.

V. Vincent Carretta's *Equiano the African: Biography of a Self-Made Man* was published by University of Georgia Press in 2005.

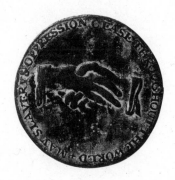

ANON
Half penny token, obverse:
*'May slavery and oppression cease
throughout the world'*,
reverse: *'Am I not a man and a brother?'*
© National Museums Liverpool, World Museum Liverpool

THE SLAVE TRADE
DEBATE ILLUSTRATED

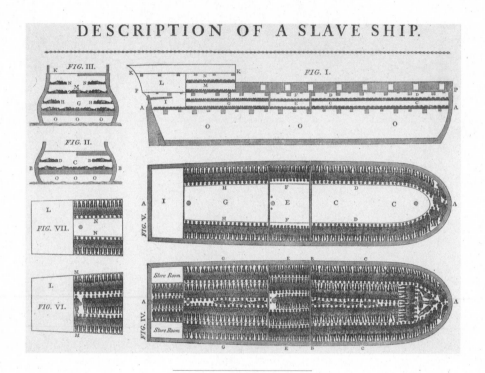

DESCRIPTION OF A SLAVE SHIP.

ANON
Description of a Slave Ship 1787
Woodcut
328 x 444 mm | BM 2000-0531-31

This is a version of a print issued by the Society for Effecting the Abolition of the Slave Trade, founded in 1787, showing the horrific conditions on slave ships on the 'middle passage' from Africa to the Caribbean colonies and the United States. It was very widely distributed. Copies were sent to all members of Parliament in 1789, and Wilberforce referred to it in his speech proposing a resolution for the abolition of the slave trade: 'The transit of the slaves in the West Indies was the most wretched part of the whole subject. So much misery condensed in so little room, is more than the human imagination had ever before conceived'. The print's effectiveness was incalculable both in Britain and abroad, and there can be no doubt that Blake was fully aware of it.

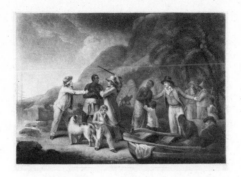

JOHN RAPHAEL SMITH (1752–1812),
after GEORGE MORLAND (1763–1804)
Slave Trade 1791 (impression 1814)
Mezzotint with some etched lines
480 x 652mm | BM 1873-0510-2604

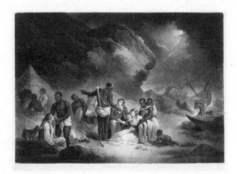

JOHN RAPHAEL SMITH,
after GEORGE MORLAND
African Hospitality 1791 (impression 1814)
Mezzotint
480 x 655mm | BM 1873-0510-2605

These two prints were made by John Raphael Smith after two paintings by George Morland. They were the subject of a pamphlet by the poet William Collins, who was a close supporter of the campaigns to lobby Parliament to outlaw the slave trade, which began in 1787 and only succeeded in 1807. Both prints are a direct appeal to sentiment, and indeed border on sentimentality. The *Slave Trade* shows an African family being split up by cruel slave traders, while *African Hospitality* shows by contrast the humanity and compassion of Africans towards a distressed European couple shipwrecked on the African coast.

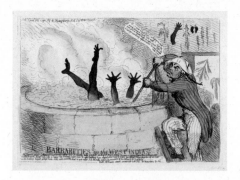

JAMES GILLRAY (1757–1815)
Barbarities in the West Indias 1791
Hand-coloured etching, published 23 April 1791
247 x 348mm | J.3-42

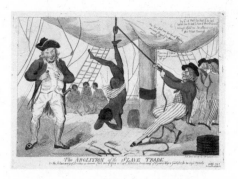

ISAAC CRUIKSHANK (1764–1811)
The Abolition of the Slave Trade 1792
Hand-coloured etching, published 10 April 1792
250 x 350mm | BM 1868-0808-6179

Top: This horrifying scene, in which a slave reporting sick was thrown into a vat of boiling sugar, was based on an incident reported by Wilberforce in support of his motion in Parliament for the abolition of the slave trade on 18 April 1791. Despite its emphasis on the cruelty of slavery, the perpetrator is clearly not a plantation owner but an overseer, many of whom were Scottish or Irish.

Bottom: Also derived from a parliamentary speech by Wilberforce, this shows the cruelty of the notorious Captain Kimber, who to Wilberforce's disgust was acquitted of the charge of the girl's murder.

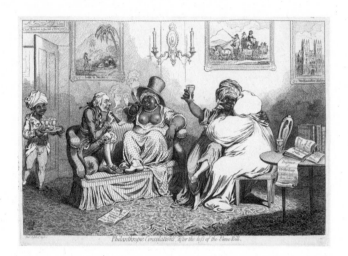

Philanthropic Consolations after the loss of the Slave Bill.

<hr>

JAMES GILLRAY
Philanthropic Consolations after the loss of the Slave Bill 1796
Coloured etching, published 4 April 1796
260 x 360mm | BM 1851-0901-787

Though Gillray had clearly shown an awareness of the cruelty of slavery (see opposite), in this print he takes a ribald view of Wilberforce and Bishop Horsley of Rochester in their failed attempts to get a bill outlawing the slave trade through Parliament on 15 March 1796. They are shown being consoled in their loss by two grateful black women. There are numerous verbal references to Wilberforce's campaign against the slave trade, and also to Captain Kimber's acquittal.

NARRATIVE,

of a five years expedition, against the

Revolted Negroes of Surinam,

in GUIANA, on the WILD COAST of

SOUTH AMERICA;

from the year 1772, to 1777:

elucidating the History of that Country, and

describing its Productions, *Viz.*

Quadrupedes, Birds, Fishes, Reptiles, Trees, Shrubs, Fruits, & Roots;

with an account of the INDIANS of Guiana, & NEGROES of Guinea.

By CAPT? J. G. STEDMAN.

illustrated with 80 elegant Engravings, from drawings made by the Author.

———— VOL. I. ————

"*O quantum terræ, quantum cognoscere cœli*
Permißum est! pelagus quantos aperimus in usus!
Nunc forsan grave, reris opus; sed lata recurret
Cum ratis, et carum cum jam mihi reddet Iolcon;
Quis pudor heu! nostros tibi tunc audire labores!
Quam referam visas tua per suspiria gentes!"

Valerius Flaccus.

London. Printed for J. Johnson, S? Paul's Church Yard, & J. Edwards, Pall Mall. 1796.

TITLE PAGE to J.G. STEDMAN
Narrative of a five years expedition against the
Revolted Negroes of Surinam, 1796
Engraving and letterpress
263 x 206mm I BM 2006-0830-43

Stedman's *Narrative* is a well-illustrated account not only of slavery and its cruelties but of the geography and natural economy of the Dutch slave colony of Surinam. Among the 80 illustrations, taken from drawings and watercolours by Stedman, there are 13 signed by and three attributed to Blake, among which are a number of images of black slaves, some of which show harrowing punishments inflicted on them. Stedman's account of the brutalities of slavery in Surinam undoubtedly affected Blake and traces of his influence can be found particularly on *Visions of the Daughters of Albion*. Blake also helped Stedman with the publication of the volume. For more on Stedman and Blake see the introductory essay to this volume, pp.11-12.

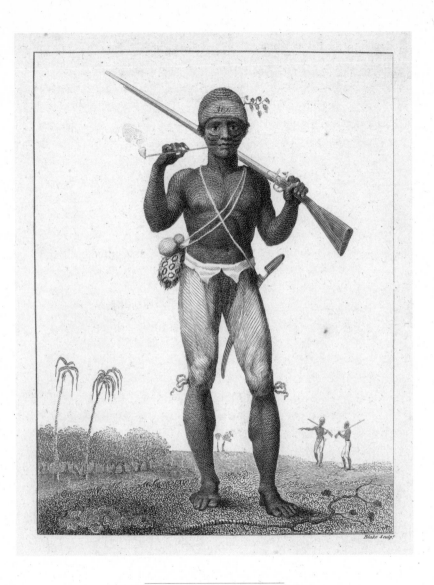

WILLIAM BLAKE after J.G. STEDMAN
A Coromantyn Free Negro, or Ranger, armed, 1793
plate facing p.80
Etching and engraving
254 x 195mm | BM 2006-0830-45

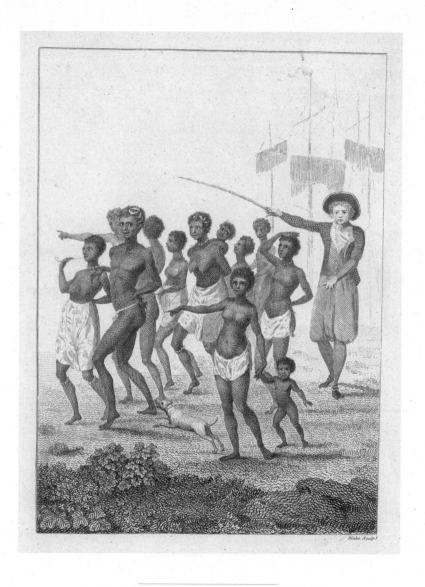

WILLIAM BLAKE after J.G. STEDMAN
Group of Negroes, as imported to be sold for Slaves, 1793
plate facing p.200
Etching and engraving
254 x 195mm | BM 2006-0830-49

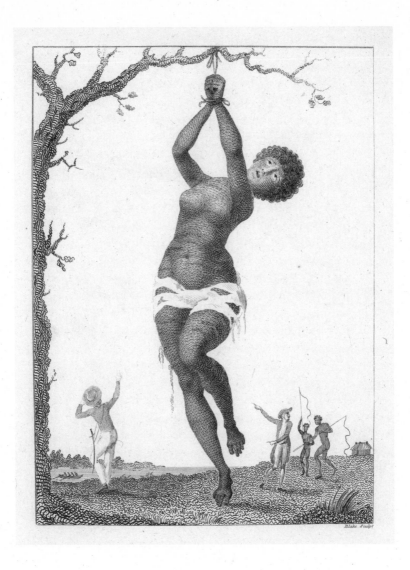

WILLIAM BLAKE after J.G. STEDMAN
Flagellation of a Female Samboe Slave, 1793
plate facing p.326
Etching and engraving
254 x 195mm | BM 2006-0830-50

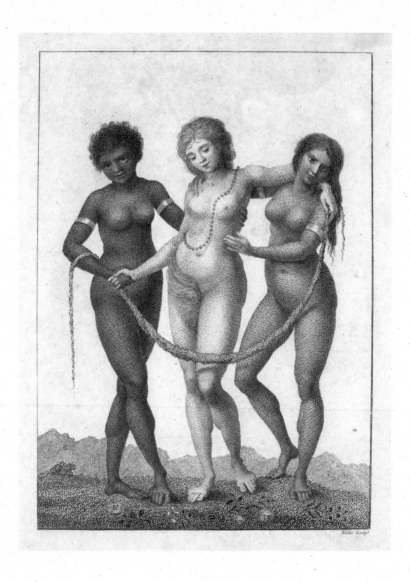

WILLIAM BLAKE after J.G. STEDMAN
Europe supported by Africa & America, 1796
Engraving
254 x 195mm | Private collection

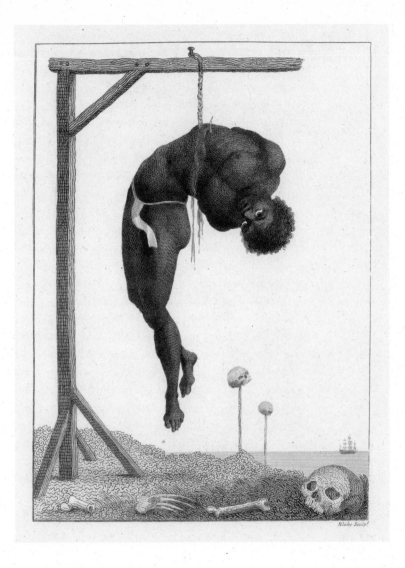

WILLIAM BLAKE after J.G. STEDMAN
A Negro hung alive by the Ribs to a Gallows, 1796
Engraving
254 x 195mm

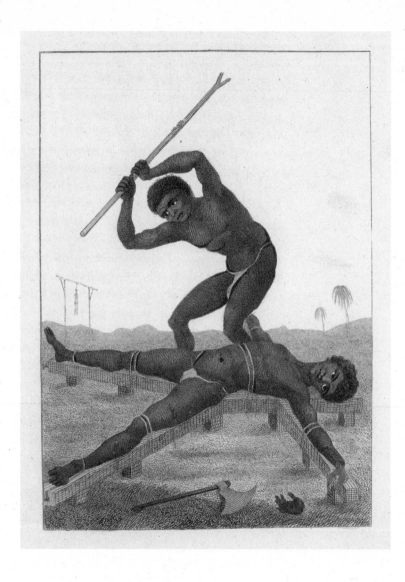

WILLIAM BLAKE after J.G. STEDMAN
The Execution of Breaking on the Rack, 1796
Engraving
254 x 195mm

ANON
Black Boy and Still
Decorative design from tobacco-paper for Margerum's Best
Virginia, at Church Street in Hackney, London,
late eighteenth century
Etching and engraving
78 x 66mm (cropped) | Heal 117-112

ANON
Black Boy Picking Tobacco with Ship in the Distance
Decorative design from tobacco-paper
late eighteenth century
Etching
50 x 39mm (cropped) | Heal 117-180

Advertisements or wrappers of the time for tobacco often show little black boys asso-
ciated with the pleasure of smoking, and giving an idealised view of the labour of the
West Indian plantations. Even so they may have influenced the language of the
Wedgwood medallion and of Blake's *Little Black Boy.*

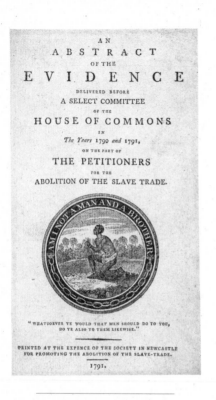

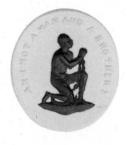

WILLIAM HACKWOOD /
JOSIAH WEDGWOOD
Slave Medallion, late 20th century,
taken from original 1787 mould
Black on cane-coloured jasper (stoneware)
33 x 30mm
Courtesy of the Trustees of the
Wedgwood Museum

THOMAS BEWICK
*Titlepage of An Abstract of the Evidence
delivered before the Select committee
of the House of Commons*
1790–91
Wood engraving | 160 x 95mm

Left: This wood engraving by the famous engraver Thomas Bewick is copied directly from the famous Wedgwood pottery medallion and it shows the immense popularity of the design.

Right: This medallion, designed by William Hackwood for Josiah Wedgwood, the great pottery manufacturer, was produced for the campaign against the slave trade, and was widely disseminated in many different forms, including costume ornaments. It is of a black boy showing gratitude for his freedom, but it also suggests that for many abolitionists freedom from slavery was not the same as freedom from servility.

42

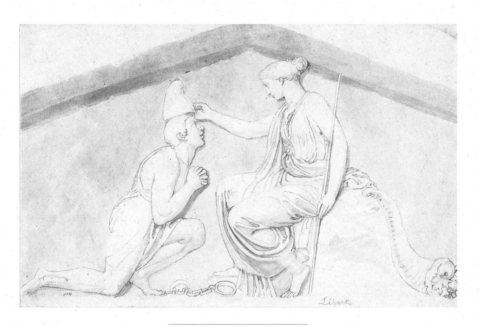

JOHN FLAXMAN (1755–1826)
Liberty freeing a Slave
c.1800
Pen and grey ink and grey wash
153 x 244mm | BM 1888-0503-53

John Flaxman, a close friend of Blake, became the most famous British sculptor of his day. This drawing is almost certainly connected with a scheme by the liberal Duke of Bedford for a Temple of Liberty in his country house Woburn Abbey. The motif of the slave showing abject gratitude for his liberty connects it in form and attitude with the Wedgwood medallion.

WILLIAM BLAKE'S
PRINTING TECHNIQUE

All the images by Blake in this catalogue, with the exception of a few watercolours and colour prints, are made in his original technique of relief etching. This is best understood as being like woodcut, using etched copper rather than wood, to print from the surface of the plate (unlike engraving which involves squeezing ink from incised lines on the copper plate). This allowed him to combine text and design freely because it avoided the use of letterpress, or pre-formed letters that were difficult to combine with images, for they both needed to be printed by separate methods. He may have written the text (with the design) on the copper in reverse, or he might have transferred it to an intermediate surface.

Each plate was hand coloured by Blake himself, but while *Songs of Innocence and of Experience* and *Visions of the Daughters of Albion* were painted in watercolour, the *First Book of Urizen* and *The House of Death* and *Albion Rose* were coloured by a method of colour printing also unique to Blake, involving the transfer of colour from a copper plate or a board. Because he printed and published every copy of every one of his 'Illuminated' books, from which most of the prints in the exhibition have been taken, in his workshop, only very small numbers were made. They are, therefore, of extreme rarity despite Blake's belief that everyone should have access to them.

Note to reader: all the relief-etched plates have been reproduced approximately to scale but the watercolours and *The House of Death* are much reduced.

PLATES

THE LITTLE BLACK BOY

Songs of Innocence and of Experience appears at first sight to be a children's book, and Blake introduced the *Songs of Innocence* in 1789 by addressing it to children. In some ways this is deceptive, not least because the *Songs of Experience*, added to *Innocence* in 1794, present a stark vision of adulthood in contrast to the innocence of childhood. The songs in either *Innocence* or *Experience* are not, however, consistent and some poems pass between the two. Nonetheless *The Little Black Boy* clearly belongs to the *Songs of Innocence* in its childish voice focused firmly on redemption, and the Black Boy himself is seen not as a slave but living freely in the 'southern wild' or Africa. *The Little Black Boy* both reflects and acts as critique of the traditional idea that a black skin represents spiritual darkness that might be redeemed by conversion to Christianity.

The Little Black Boy
Plate 1 from *Songs of Innocence and of Experience*, copy B, 1789
Relief etching, printed in brown ink and coloured by Blake
110 x 69mm I BM 1932-1210-7v

These two plates from the series of illuminated poems *Songs of Innocence* were written, illustrated, coloured and printed by Blake. The poem reiterates the ancient idea that a black body might contain a white soul capable of Christian redemption, but it is likely that Blake intended it as an ironical critique of the conventional assumption of black servility towards those with white skin. It precedes by some years Blake's exposure to the realities of slavery in his work for Stedman's *Surinam*, but it was still probably prompted by the recent beginning of the campaign against the slave trade.

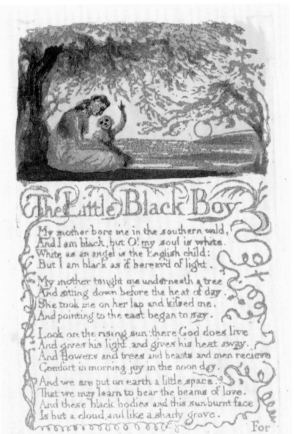

The Little Black Boy

My mother bore me in the southern wild,
And I am black, but O! my soul is white.
White as an angel is the English child:
But I am black as if bereav'd of light.

My mother taught me underneath a tree
And sitting down before the heat of day
She took me on her lap and kissed me.
And pointing to the east began to say.

Look on the rising sun: there God does live
And gives his light and gives his heat away.
And flowers and trees and beasts and men recieve
Comfort in morning joy in the noon day.

And we are put on earth a little space.
That we may learn to bear the beams of love.
And these black bodies and this sun-burnt face
Is but a cloud and like a shady grove.

For

The Little Black Boy
Plate 2 from *Songs of Innocence and of Experience*, copy B, 1789
Relief etching, printed in brown ink and coloured by Blake
103 x 64mm | BM 1932-1210-8r

For when our souls have learn'd the heat to bear
The cloud will vanish we shall hear his voice.
Saying: come out from the grove my love & care,
And round my golden tent like lambs rejoice.

Thus did my mother say and kissed me,
And thus I say to little English boy.
When I from black and he from white cloud free.
And round the tent of God like lambs we joy:

Ill shade him from the heat till he can bear,
To lean in joy upon our fathers knee.
And then ill stand and stroke his silver hair,
And be like him and he will then love me.

MENTAL SLAVERY
'MIND-FORG'D MANACLES'
AND THE CHAINING OF DESIRE

This section introduces Blake's idea of mental slavery, the way in which the mind can be imposed on by others, but can also enslave itself by false belief and adherence to a materialist philosophy, under the influence of conventional religion and Locke and Newton's rationalism, both of which Blake abhorred.

London
Plate 36 from *Songs Of Innocence and of Experience*, copy B, 1794
Relief etching in orange and black, coloured by Blake
110 x 69mm I BM 1932-1210-22v

This poem comes from the *Songs of Experience*, hence its dark tone,
and awareness of the terrors of contemporary society, in this case of
London life. If in the *Innocence* poems the setting is primarily
pastoral, here it is the city where the fallen state of Experience is
fully undergone. The poem expresses the idea in its reference to
'Mind-forg'd Manacles' that enslavement to false values and the
materialism of society can be self-inflicted.

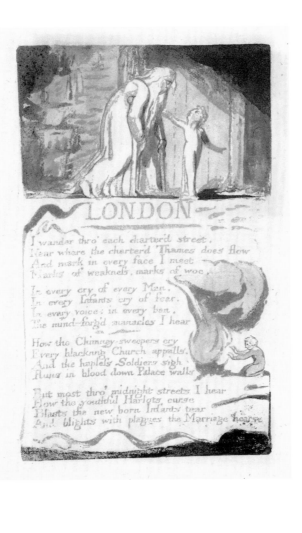

LONDON

I wander thro' each charter'd street,
Near where the charter'd Thames does flow
And mark in every face I meet
Marks of weakness, marks of woe.

In every cry of every Man,
In every Infants cry of fear,
In every voice: in every ban,
The mind-forg'd manacles I hear

How the Chimney-sweepers cry
Every blackning Church appalls,
And the hapless Soldiers sigh
Runs in blood down Palace walls

But most thro' midnight streets I hear
How the youthful Harlots curse
Blasts the new born Infants tear
And blights with plagues the Marriage hearse

The Ecchoing Green
Plate 8 from *Songs Of Innocence*, copy B, 1794
Relief etching, coloured by Blake, 1794
108 x 69mm I BM 1932-1210-6r

In *The Ecchoing Green* the state of childhood is synonymous with innocence and freedom, protected by the ideal harmony of a contented village. It is also the state of Eden, the pastoral paradise that precedes the fall into a world in which the natural freedom of childhood is curbed by cruel and tyrannical authority.

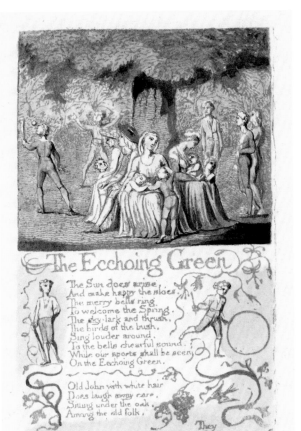

The Ecchoing Green

The Sun does arise,
And make happy the skies.
The merry bells ring
To welcome the Spring.
The sky-lark and thrush,
The birds of the bush,
Sing louder around,
To the bells chearful sound.
While our sports shall be seen
On the Ecchoing Green.

Old John with white hair
Does laugh away care,
Sitting under the oak,
Among the old folk,

They

The Garden of Love
Plate 43 from *Songs Of Experience*, copy B, 1794
Relief etching, coloured by Blake
110 x 67mm I BM 1932-1210-26r

In *The Garden of Love* all the imagery suggests repression and prohibition of the artless joy of the state of innocence, as depicted in *The Ecchoing Green*. This prohibition is guided by the religion of the church, and is part of current society's attempt to chain the mind to materialism and thoughts of the physical nature of death. The priests in effect forge the manacles that enslave the mind, but are themselves mentally manacled.

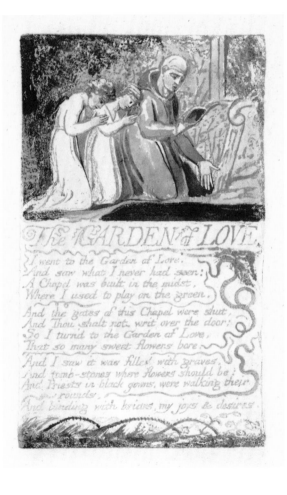

THE GARDEN OF LOVE.

I went to the Garden of Love,
And saw what I never had seen:
A Chapel was built in the midst,
Where I used to play on the green.

And the gates of this Chapel were shut,
And Thou shalt not, writ over the door;
So I turnd to the Garden of Love,
That so many sweet flowers bore,

And I saw it was filled with graves,
And tomb-stones where flowers should be:
And Priests in black gowns, were walking their
rounds,
And binding with briars, my joys & desires.

Plate 1, frontispiece from
Visions of the Daughters of Albion, copy B, 1793
Hand-coloured relief etching printed in brown ink
170 x 118mm I BM 1953-0101-1-11v

The three protagonists of *Visions of the Daughters of Albion*, from
which this and the following three plates are taken, represent differ-
ent forms of enslavement: Bromion, the husband, on the left is
chained to his wife Oothoon who seeks liberty; on the right is
Theotormon, her ineffectual lover whose manacles are 'mind-forg'd'.
The brutal Bromion rapes Oothoon and is characterised by Blake as a
slave owner who treats his wife as a possession. This plate acts in
some copies of the book as the frontispiece to the *Visions* and in
others it is the last plate.

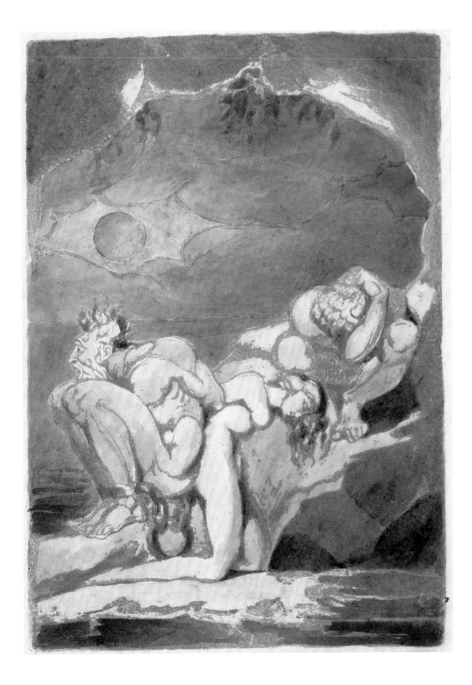

Enslaved the Daughters of Albion weep
Plate 4 from *Visions of the Daughters of Albion,* copy B, 1793
Hand-coloured relief etching printed in brown ink
170 x 117mm | BM 1953-0101-1-13r

Oothoon represents the women of England (the daughters of Albion), who are enslaved by society and conventional marriage, sighing towards America, the land of liberty. Bromion identifies himself as a slave owner ('Stampt with my signet are the swarthy children of the sun'); his relationship to Oothoon is one of master to slave. On the back of this plate is the next page of text, which contains an image of a slave collapsed with exhaustion.

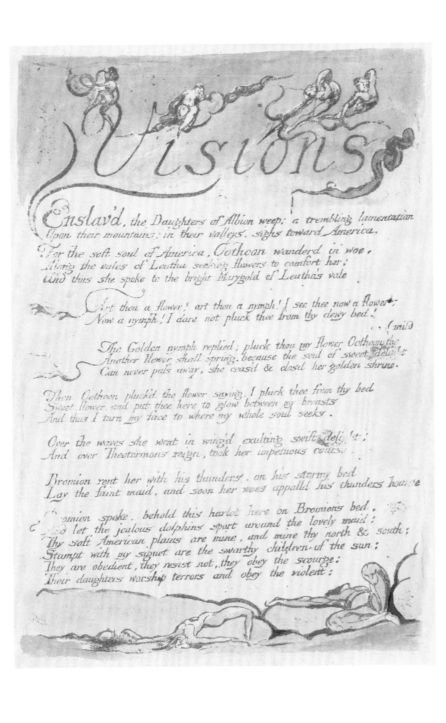

Visions

Enslav'd, the Daughters of Albion weep; a trembling lamentation
Upon their mountains; in their valleys, sighs toward America.

For the soft soul of America, Oothoon wanderd in woe,
Along the vales of Leutha seeking flowers to comfort her;
And thus she spoke to the bright Marygold of Leutha's vale

 Art thou a flower! art thou a nymph! I see thee now a flower;
 Now a nymph! I dare not pluck thee from thy dewy bed!

 The golden nymph replied; pluck thou my flower Oothoon the mild
 Another flower shall spring, because the soul of sweet delight
 Can never pass away, she ceased & closd her golden shrine.

Then Oothoon pluckd the flower saying, I pluck thee from thy bed
Sweet flower, and put thee here to glow between my breasts
And thus I turn my face to where my whole soul seeks.

Over the waves she went in wing'd exulting swift delight;
And over Theotormons reign, took her impetuous course.

Bromion rent her with his thunders, on his stormy bed
Lay the faint maid, and soon her woes appalld his thunders hoarse

Bromion spoke, behold this harlot here on Bromions bed,
And let the jealous dolphins sport around the lovely maid;
Thy soft American plains are mine, and mine thy north & south:
Stampt with my signet are the swarthy children of the sun;
They are obedient, they resist not, they obey the scourge:
Their daughters worship terrors and obey the violent:

Wave shadows of discontent?
Plate 7 from *Visions of the Daughters of Albion*, copy B, 1793
Hand-coloured relief etching printed in brown ink
170 x 117mm I BM 1953-0101-1-14v

Though Oothoon aspires to break free she is still chained by a mana-
cle to the earth, while Theotormon is locked in impotent despair.
Neither for different reasons is able to break free.

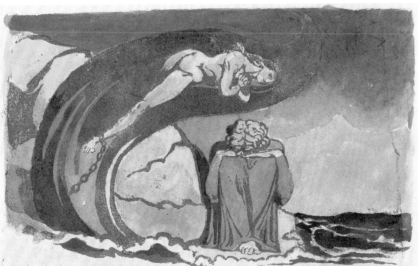

Wave shadows of discontent! and in what houses dwell the wretched
Drunken with woe forgotten. and shut up from cold despair.

Tell me where dwell the thoughts forgotten till thou call them forth
Tell me where dwell the joys of old! & where the ancient loves?
And when will they renew again & the night of oblivion past?
That I might traverse times & spaces far remote and bring
Comforts into a present sorrow and a night of pain
Where goest thou O thought! to what remote land is thy flight?
If thou returnest to the present moment of affliction
Wilt thou bring comforts on thy wings. and dews and honey and balm;
Or poison from the desert wilds. from the eyes of the envier.

4 JY 59

Then Bromion said: and shook the cavern with his lamentation

Thou knowest that the ancient trees seen by thine eyes have fruit:
But knowest thou that trees and fruits flourish upon the earth
To gratify senses unknown? trees beasts and birds unknown:
Unknown, not unperceivd, spread in the infinite microscope,
In places yet unvisited by the voyager. and in worlds
Over another kind of seas. and in atmospheres unknown:
Ah! are there other wars, beside the wars of sword and fire!
And are there other sorrows, beside the sorrows of poverty?
And are there other joys, beside the joys of riches and ease?
And is there not one law for both the lion and the ox?
And is there not eternal fire, and eternal chains?
To bind the phantoms of existence from eternal life?

Then Oothoon waited silent all the day. and all the night.

Final Plate from *Visions of the Daughters of Albion*, copy B, 1793
Hand-coloured relief etching printed in brown ink
170 x 119mm | BM 1953-0101-1-16v

Oothoon flies above the coast of England watched by a huddled group
of the Daughters of Albion, lamenting her fate, still unable to free
herself or her sisters who remain repressed.

Where the cold miser spreads his gold.' or does the bright cloud
On his stone threshold,' does his eye behold the beam that brings
Expansion to the eye of pity.' or will he bind himself
Beside the ox to thy hard furrow.' does not that mild beam blot
The bat, the owl, the glowing tyger, and the king of night.
The sea fowl takes the wintry blast, for a covring to her limbs:
And the wild snake, the pestilence to adorn him with gems & gold.
And trees, & birds, & beasts, & men, behold their eternal joy.
Arise you little glancing wings, and sing your infant joy.'
Arise and drink your bliss, for every thing that lives is holy.'

Thus every morning wails Oothoon, but Theotormon sits
Upon the margind ocean conversing with shadows dire.

The Daughters of Albion hear her woes, & eccho back her sighs.

The End

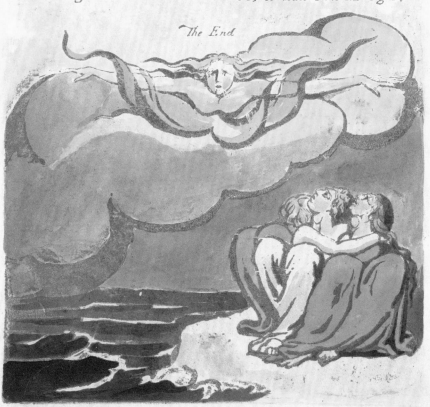

Titlepage from *The First Book of Urizen*, copy D, 1794
Relief etching colour printed, with hand colouring
147 x 102mm I BM 1859-0625-46

The First Book of Urizen is dated a year later than *America: A Prophecy*, which introduces Blake's myth as it applies to the contemporary revolutionary world. *Urizen*, however, tells the story of the origins of the myth and the creation of the material world under the dominance of the tyrannical Urizen, who embodies in his person reason, materialism, legalism, and the narrow perceptions of those whose minds are enslaved. In one sense he represents an inevitable part of the mental make-up of man, but he is also a composite of the God of the Old Testament (here symbolised by the Tablets of the Law in the background), of the classical Zeus, and even the tyrants of Blake's own day. In this titlepage he is shown sightlessly writing and possibly engraving with an implement in each hand.

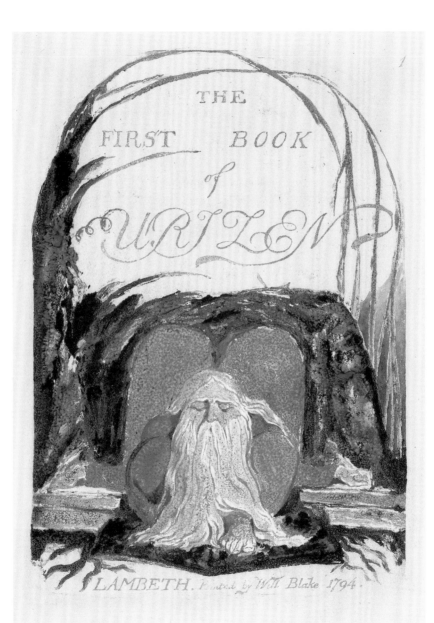

THE

FIRST BOOK

of

URIZEN

LAMBETH. Printed by Will. Blake 1794.

Urizen holding a landscape book
Plate 4 from *The First Book of Urizen*, copy D, 1794
Relief etching colour printed, with hand colouring.
149 x 107mm | BM 1859-0625-49

For Blake the essence of the spiritual world was clarity; vagueness
and mystification were a sign of false religion, expressed here in a
murky and incoherent book that Urizen offers to humanity.

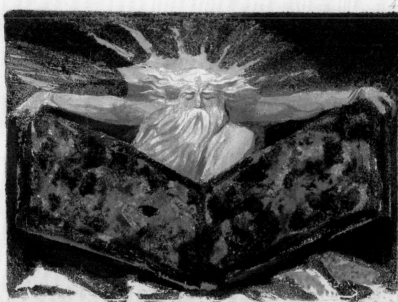

In living creations appeard
In the flames of eternal fury.

3. Sundring, darkning, thundring!
Rent away with a terrible crash
Eternity rolld wide apart
Wide asunder rolling
Mountainous all around
Departing; departing; departing:
Leaving ruinous fragments of life
Hanging frowning cliffs & all between
An ocean of voidness unfathomable.

4. The roaring fires ran o'er the heavns
In whirlwinds & cataracts of blood
And o'er the dark deserts of Urizen
Fires pour thro' the void on all sides
On Urizens self-begotten armies.

5. But no light from the fires, all was
darkness
In the flames of Eternal fury

6. In fierce anguish & quenchless
flames

To the deserts and rocks he ran raging
To hide, but he could not: combining
He dug mountains & hills in vast strength,
He piled them in incessant labour,
In howlings & pangs & fierce madness
Long periods in burning fires labouring
Till hoary, and age-broke, and aged,
In despair and the shadows of death.

7. And a roof vast petrific around,
On all sides he fram'd: like a womb;
Where thousands of rivers in veins
Of blood pour down the mountains to cool
The eternal fires beating without
From Eternals; & like a black globe
Viewd by sons of Eternity, standing
On the shore of the infinite ocean
Like a human heart strugling & beating
The vast world of Urizen appear'd.

8. And Los round the dark globe of
Urizen,
Kept watch for Eternals to confine,
The obscure separation alone;
For Eternity stood wide apart

Los with skeleton in chains
Plate 10 from *The First Book of Urizen*, copy D, 1794
Relief etching colour printed with hand colouring
151 x 109mm I BM 1859-0625-55

Los as the eternal poet has the task of giving form to the powers of the world. Hence he is the creator of the body of Urizen, here seen as a skeleton being forged into a still incomplete living being, held down by manacles.

Urizen.

7. From the caverns of his jointed Spine,
Down sunk with fright a red
Round globe hot burning deep
Deep down into the Abyss:
Panting: Conglobing, Trembling
Shooting out ten thousand branches
Around his solid bones.
And a second Age passed over,
And a state of dismal woe.

8. In harrowing fear rolling round;
His nervous brain shot branches
Round the branches of his heart
On high into two little orbs
And fixed in two little caves

Hiding carefully from the wind.
His Eyes beheld the deep.
And a third Age passed over;
And a state of dismal woe.

9. The pangs of hope began.
In heavy pain striving, struggling.
Two Ears in close volutions;
From beneath his orbs of vision
Shot spiring out and petrified
As they grew. And a fourth Age pass
And a state of dismal woe.

10. In ghastly torment sick;
Hanging upon the wind;

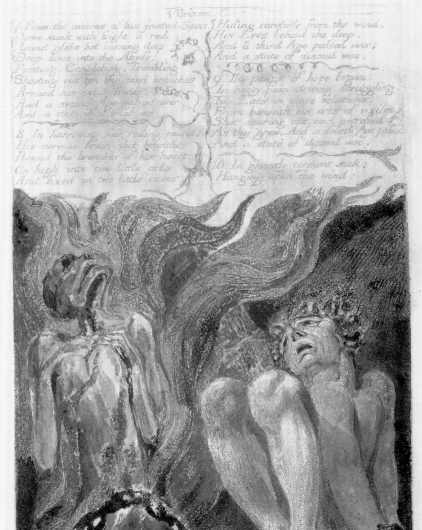

Orc with Enitharmon and Los
Plate 19 from *The First Book of Urizen*, Copy D, 1794
Relief etching colour printed, with hand colouring
166 x 101mm I BM 1859-0625-64

The image of Los, his partner Enitharmon and Orc, the spirit of revolution (for whom see the next section), shows a scene of familial jealousy symbolised by the ever-renewing chain around Los which represents, in David Worrall's words, 'forms of enslavement …parental and sexual'. This Chain of Jealousy that girdles Los' chest as he watches Orc's embrace of his mother leads Los to chain him to a rock, and thus thwart man's revolutionary potential for thousands of years, from which he breaks free at the beginning of *America a Prophecy*. Blake saw artists as susceptible to jealousy, particularly those, like himself, gifted but unrecognised.

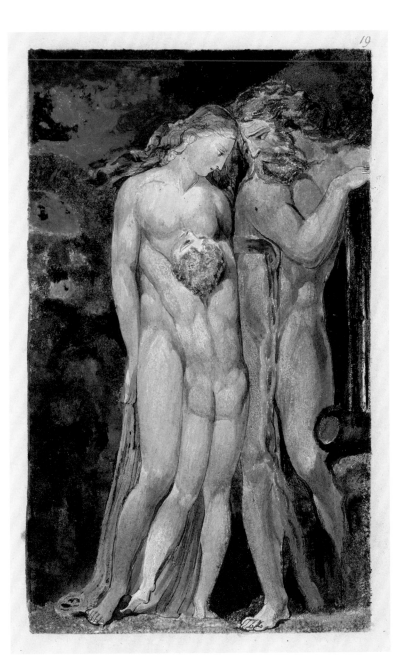

Urizen in Chains
Plate 20 from *The First Book of Urizen*, Copy D, 1794
Relief etching colour printed, with hand colouring.
157 x 100mm I BM 1859-0625-65

The definitive image of the idea that those with the most material power are also the most enslaved, for Urizen as 'the God of This World' is manacled by his limited perceptions.

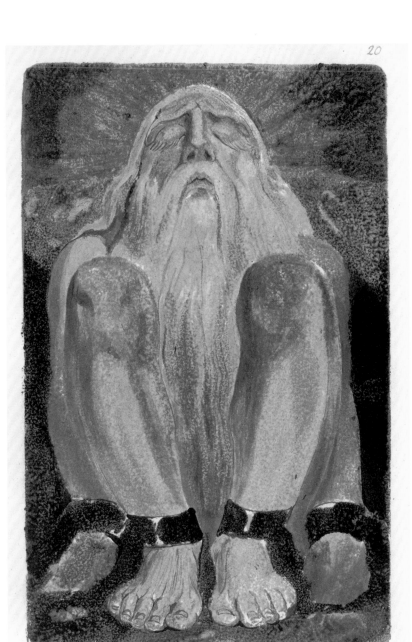

Urizen in Net
Plate 26 from *The First Book of Urizen*, Copy D, 1794
Relief etching colour printed with hand colouring.
151 x 102 mm I BM 1859-0625-71

The final plate of the volume represents the beginnings of life on earth when mankind was confined 'Beneath the Net of Urizen', as he exercises his malign power over the emergent world.

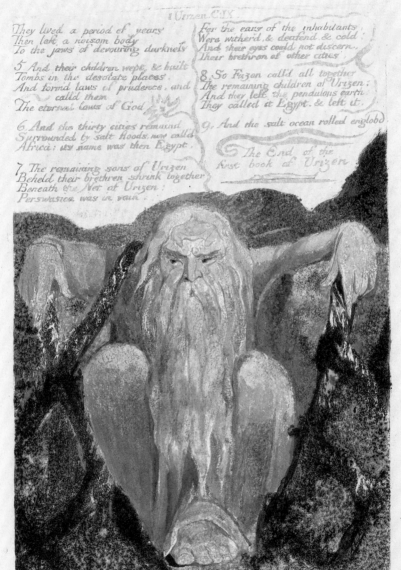

I Urizen CH X

They lived a period of years
Then left a noisom body
To the jaws of devouring darkness

5 And their children wept, & built
Tombs in the desolate places.
And formd laws of prudence, and
called them
The eternal laws of God

6 And the thirty cities remaind
Surrounded by salt floods, now calld
Africa: its name was then Egypt.

7 The remaining sons of Urizen
Beheld their brethren shrink together
Beneath the Net of Urizen:
Perswasion was in vain

For the ears of the inhabitants
Were witherd, & deafend, & cold:
And their eyes could not discern,
Their brethren of other cities

8 So Urizen calld all together
The remaining children of Urizen:
And they left the pendulous earth
They called it Egypt, & left it.

9, And the salt ocean rolled englobd

The End of the
first book of Urizen.

The House of Death or *The Lazar-House of Milton*, 1795–1805
Colour print, finished in pen and watercolour
472 x 590mm I BM 1885-0509-1616

One of a series of 12 large scale colour prints of various subjects
taken from the Bible and literature, which exist normally in two or
three impressions each. A grim vision of the world as a madhouse
presided over by the sightless 'God of this World'.

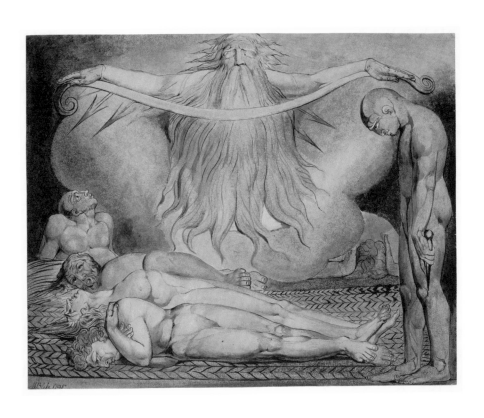

THROWING OFF THE CHAINS
REVOLUTION

America: A Prophecy of 1793 tells in mythical terms the story of the American Revolution of 1776, its challenge to the British government and Anglican church, and its failure to set England alight in revolution. It centres on the enchained figure of Orc or revolution and his breaking of his chains to confront Urizen, who represents in this context tyranny and false religion based on reason.

Preludium
Plate 3 from *America: A Prophecy*, Copy F, 1793
Relief etching
252 x 165mm I BM 1953-0101-1-3r

Los and Enitharmon, the parents of Orc, lament over their son who is manacled to a rock, as a consequence of Los' jealousy (see *The First Book of Urizen*, p.74). Orc is about to break his chains, and challenge the old order represented by Urizen.

Preludium

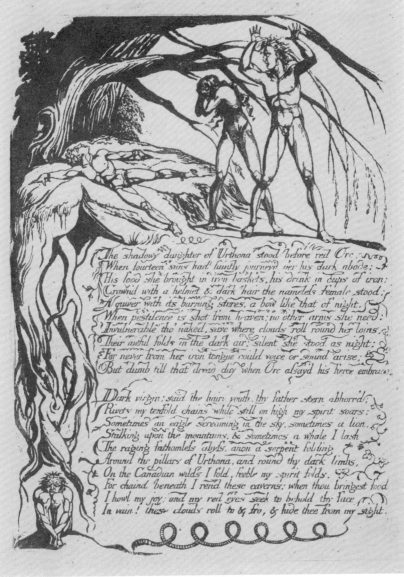

The shadowy daughter of Urthona stood before red Orc.
When fourteen suns had faintly journeyd oer his dark abode;
His food she brought in iron baskets, his drink in cups of iron:
Crownd with a helmet & dark hair the nameless female stood;
A quiver with its burning stores, a bow like that of night,
When pestilence is shot from heaven; no other arms she need:
Invulnerable tho' naked, save where clouds roll round her loins,
Their awful folds in the dark air; silent she stood as night;
For never from her iron tongue could voice or sound arise;
But dumb till that dread day when Orc assay'd his fierce embrace.

Dark virgin; said the hairy youth, thy father stern abhorr'd;
Rivets my tenfold chains while still on high my spirit soars;
Sometimes an eagle screaming in the sky, sometimes a lion,
Stalking upon the mountains, & sometimes a whale I lash
The raging fathomless abyss, anon a serpent folding
Around the pillars of Urthona, and round thy dark limbs,
On the Canadian wilds I fold, feeble my spirit folds,
For chaind beneath I rend these caverns; when thou bringest food
I howl my joy; and my red eyes seek to behold thy face
In vain! these clouds roll to & fro, & hide thee from my sight.

The morning comes, the night decays
Plate 8 from *America: A Prophecy*, Copy F, 1793
Relief etching
238 x 167mm I BM 1953-0101-1-5v

An image of the liberation of man as a consequence of Orc's breaking
of his chains, a metaphor of the outbreak of the American Revolution,
some 16 years previous to the publication of *America*. In this new
awakening of humanity the text on this page is exultant, as if libera-
tion were a dramatic event, in which 'the slave grinding at the mill,
run[s] out into the field'. Yet the image shows the slave still seated on
the earth with a skull, signifying the death of the body, next to him as
he looks around in quiet wonderment at his freedom.

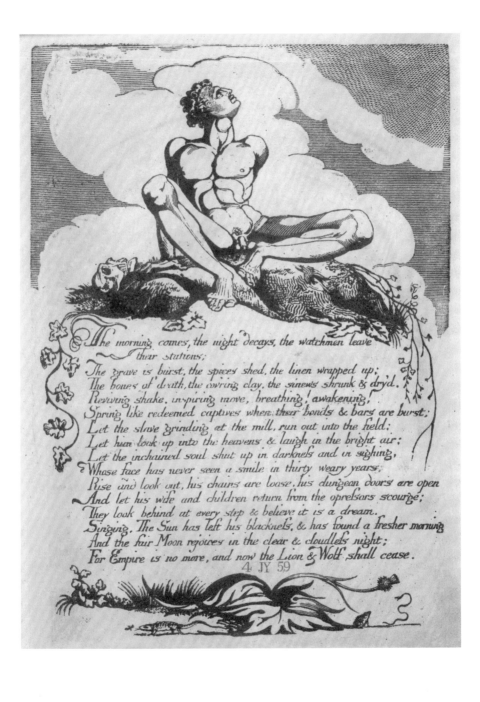

The morning comes, the night decays, the watchmen leave
 their stations;
The grave is burst, the spices shed, the linen wrapped up;
The bones of death, the cov'ring clay, the sinews shrunk & dry'd,
Reviving shake, inspiring move, breathing! awakening!
Spring like redeemed captives when their bonds & bars are burst;
Let the slave grinding at the mill, run out into the field:
Let him look up into the heavens & laugh in the bright air;
Let the inchained soul shut up in darkness and in sighing,
Whose face has never seen a smile in thirty weary years;
Rise and look out, his chains are loose, his dungeon doors are open
And let his wife and children return from the opressors scourge;
They look behind at every step & believe it is a dream.
Singing, The Sun has left his blackness, & has found a fresher morning
And the fair Moon rejoices in the clear & cloudless night;
For Empire is no more, and now the Lion & Wolf shall cease.

4 JY 59

The Terror answerd (Urizen)
Plate 10 from *America: A Prophecy*, Copy F, 1793
Relief etching
231 x 167mm I BM 1953-0101-1-6v

The fiery Orc liberated from his chains rises up to confront Urizen who stands for all forms of repression of true religion and 'the fiery joy, that Urizen perverted to ten commands'. Orc threatens to stamp to dust 'that stony law', represented in the title page to *The Book of Urizen* (See p.68) by Moses' Tablets of the Law behind him.

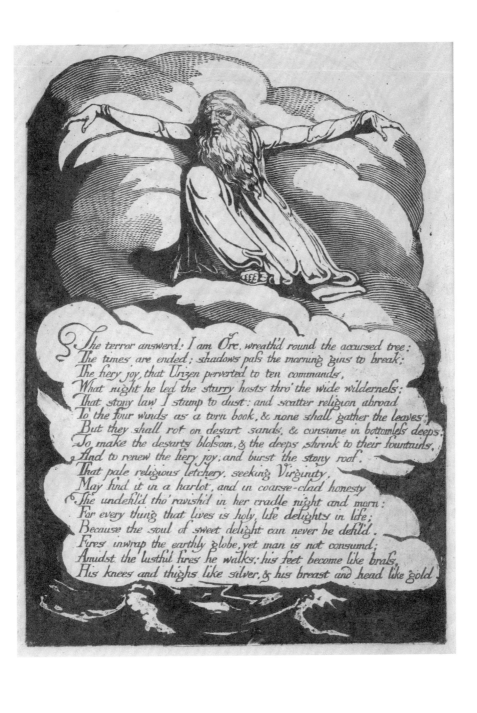

The terror answerd: I am Orc, wreath'd round the accursed tree:
The times are ended; shadows pass the morning gins to break;
The fiery joy, that Urizen perverted to ten commands,
What night he led the starry hosts thro' the wide wilderness:
That stony law I stamp to dust: and scatter religion abroad
To the four winds as a torn book, & none shall gather the leaves;
But they shall rot on desart sands, & consume in bottomless deeps,
To make the desarts blossom, & the deeps shrink to their fountains,
And to renew the fiery joy, and burst the stony roof.
That pale religious letchery, seeking Virginity,
May find it in a harlot, and in coarse-clad honesty
The undefil'd tho' ravish'd in her cradle night and morn:
For every thing that lives is holy, life delights in life;
Because the soul of sweet delight can never be defil'd.
Fires inwrap the earthly globe, yet man is not consumd;
Amidst the lustful fires he walks; his feet become like brass,
His knees and thighs like silver, & his breast and head like gold.

Thus wept the Angel voice (Orc)
Plate 12 from *America: A Prophecy*, Copy F, 1793
Relief etching
233 x 167mm I BM 1953-0101-1-7v

While the text refers to the outbreak of the American Revolution the image shows the ascendant Orc rising in flames to challenge Urizen, whose clouds will be evaporated by the revolutionary heat.

Thus wept the Angel voice & as he wept the terrible blasts
Of trumpets, blew a loud alarm across the Atlantic deep.
No trumpets answer; no reply of clarions or of fifes,
Silent the Colonies remain and refuse the loud alarm.

On those vast shady hills between America & Albions shore;
Now barrd out by the Atlantic sea; calld Atlantean hills;
Because from their bright summits you may pass to the Golden world
An ancient palace, archetype of mighty Emperies.
Rears its immortal pinnacles, built in the forest of God
By Ariston the king of beauty for his stolen bride.

4 JY 59

Here on their magic seats the thirteen Angels sat perturbd
For clouds from the Atlantic hover oer the solemn roof.

Plate 18 (final plate) from *America: A Prophecy*, Copy F, 1793
Relief etching
235 x 173mm I BM 1953-0101-1-10v

Urizen is shown damping down 'the red flames fierce' of revolution by pouring on them ice and snow, a reference to the fact that the American Revolution did not spread to Britain, but broke out again in France some twelve years later, i.e. in 1789, for Urizen was then 'unable to stem the fires of Orc'.

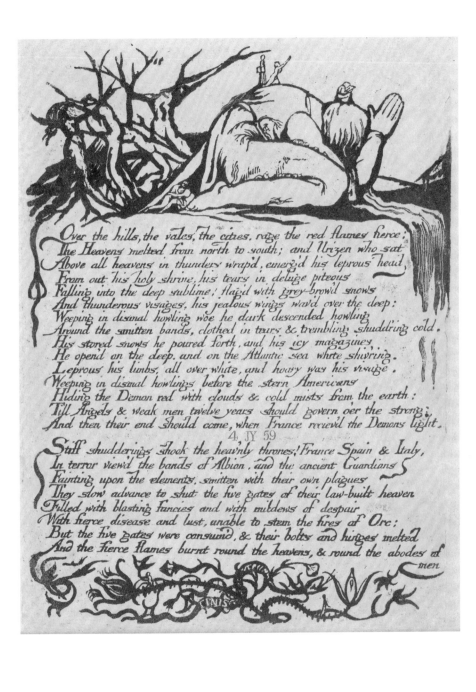

Over the hills, the vales, the cities, rage the red flames fierce:
The Heavens melted from north to south; and Urizen who sat
Above all heavens in thunders wrap'd, emerg'd his leprous head,
From out his holy shrine, his tears in deluge piteous
Falling into the deep sublime! flag'd with grey-brow'd snows
And thunderous visages, his jealous wings wav'd over the deep;
Weeping in dismal howling woe he dark descended howling
Around the smitten bands, clothed in tears & trembling shudd'ring cold.
His stored snows he poured forth, and his icy magazines
He open'd on the deep, and on the Atlantic sea white shiv'ring.
Leprous his limbs, all over white, and hoary was his visage.
Weeping in dismal howlings before the stern Americans
Hiding the Demon red with clouds & cold mists from the earth:
Till Angels & weak men twelve years should govern o'er the strong:
And then their end should come, when France reciev'd the Demons light.

4, JY 59

Stiff shudderings shook the heav'nly thrones! France Spain & Italy,
In terror view'd the bands of Albion, and the ancient Guardians
Fainting upon the elements, smitten with their own plagues
They slow advance to shut the five gates of their law-built heaven
Filled with blasting fancies and with mildews of despair
With fierce disease and lust, unable to stem the fires of Orc;
But the five gates were consum'd, & their bolts and hinges melted
And the fierce flames burnt round the heavens, & round the abodes of
 men

Albion rose...
(known as *Glad Day* or *The Dance of Albion*), c.1803—10
Engraving, etching and drypoint
255 x 190mm I BM 1894-0612-27

A separate plate that was apparently first conceived in Blake's youth
in 1780 (no impressions are known), then offered in colour printed
form, then reissued as an etching c.1804—05. Another impression
(Huntington Library, San Marino, California) has the caption 'Albion
rose from where he labour'd at the Mill with Slaves/Giving himself
for the Nations he danc'd the dance of Eternal Death'. This image of
Albion, the everyman who also represents Britain, shows in its purest
form Blake's desire for the transforming state of liberation from all
constraints, physical and spiritual. Slavery and liberty are thus
represented as both of the body and the soul.

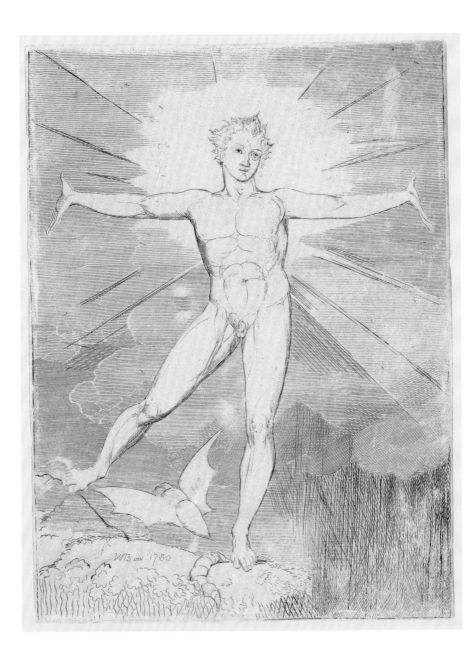

THE WORLD AS PRISON
DEATH AS LIBERATION

Edward Young's *Night Thoughts* and Blair's *The Grave* were popular 'Graveyard' poems of the mid-eighteenth century that argued for the reality of the afterlife in the face of the growth of a more materialistic philosophy in that period. Blake's watercolours pick up on the themes of the liberation from the body and the material world in death. Though Blake had reservations about Young's and Blair's attachment to the Church of England he fully supported the emphasis on the ultimate triumph of the spirit in both poems, though the illustrations were also a commercial venture and a showcase of his talents for him and his publishers. Blake made a total of 537 watercolours for the *Night Thoughts* (all in the British Museum) over a period of two years. They were designed as the basis for a printed and engraved edition, but in the end only one volume with 43 plates was published in 1797.

Queen Katherine's Dream,
from William Shakespeare's *Henry VIII*, 1809
Pen and grey ink, and watercolour
307 x 194mm I BM 1954-1113-1-22

One of a group of watercolours commissioned to go in a Shake-
speare Second Folio, it shows the dying dream of Henry VIII's rejected
wife Katherine of Aragon. On her deathbed she glimpses a better
world than she had endured in her tragic life. Death is a merciful
release from the prison of the world.

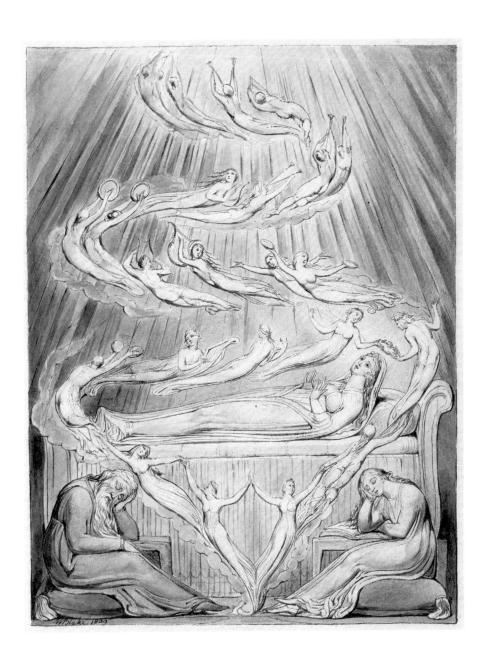

Illustration to Edward Young's *Night Thoughts*, 1796–97
Night 1, p.12 'O how self-fetter'd was my groveling Soul?'
Pen and watercolour
420 x 325mm (approx) I BM 1929-0713-9v

Illustrates the lines:

O how self-fetter'd was my groveling Soul?
How, like a Worm, was I wrapt round and round
In silken thought, which reptile Fancy spun,
Till darken'd Reason lay quite clouded o'er
With soft conceit of endless Comfort here,
Nor yet put forth her Wings to reach the skies?

Blake creates from these words a characteristic conjunction of ideas
and images. It shows a mind 'self-fetter'd', that is to say self-enclosed
and confined, unable in its self-absorption to reach beyond
the rational.

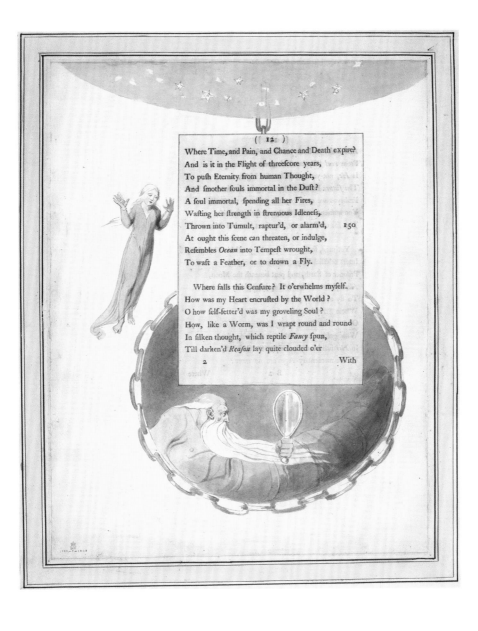

(12)

Where Time, and Pain, and Chance and Death expire?
And is it in the Flight of threescore years,
To push Eternity from human Thought,
And smother souls immortal in the Dust?
A soul immortal, spending all her Fires,
Wasting her strength in strenuous Idleness,
Thrown into Tumult, raptur'd, or alarm'd, 150
At ought this scene can threaten, or indulge,
Resembles *Ocean* into Tempest wrought,
To waft a Feather, or to drown a Fly.

 Where falls this Censure? It o'erwhelms myself.
How was my Heart encrusted by the World?
O how self-fetter'd was my groveling Soul?
How, like a Worm, was I wrapt round and round
In silken thought, which reptile *Fancy* spun,
Till darken'd *Reason* lay quite clouded o'er

2 With

Illustrations to Edward Young's *Night Thoughts*, 1796–97
Night 1, p.18 'And plough the Winter's wave'
Pen and watercolour
420 x 325mm (approx) I BM 1929-0713-12v

A victim of tyranny like a miner who 'forgets a Sun was made',
Young's oarsman is 'hammered to the galling Oar for life', forced to
'plough the Winter's wave, and reap Despair'. This is not so much
mental slavery as the hazards of life on earth, though with Blake
physical and mental tyranny are closely allied.

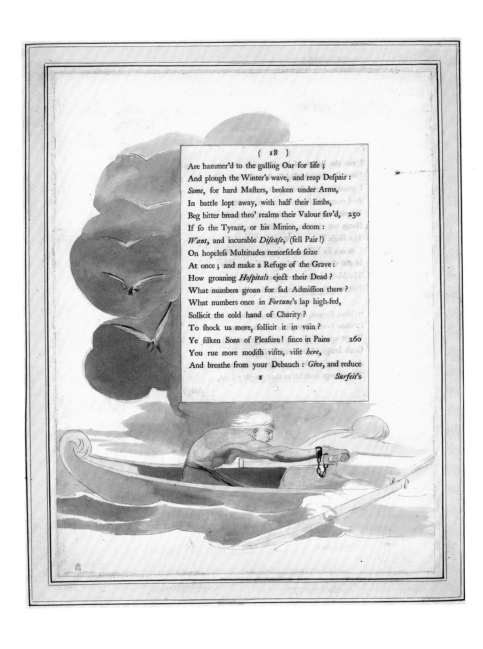

(18)

Are hammer'd to the galling Oar for life ;
And plough the Winter's wave, and reap Despair :
Some, for hard Masters, broken under Arms,
In battle lopt away, with half their limbs,
Beg bitter bread thro' realms their Valour sav'd, 250
If so the Tyrant, or his Minion, doom :
Want, and incurable *Disease*, (fell Pair !)
On hopeless Multitudes remorseless seize
At once ; and make a Refuge of the Grave :
How groaning *Hospitals* eject their Dead ?
What numbers groan for sad Admission there ?
What numbers once in *Fortune*'s lap high-fed,
Sollicit the cold hand of Charity ?
To shock us more, follicit it in vain ?
Ye silken Sons of Pleasure ! since in Pains 260
You rue more modish visits, visit *here*,
And breathe from your Debauch : *Give*, and reduce

Surfeit's

Illustrations to Edward Young's *Night Thoughts*, 1796—97,
Night III, p.30 'Death but entombs the Body: Life the Soul'
Pen and watercolour
420 x 325mm (approx) | BM 1929-0713-53v

Young contrasts life and death, arguing that life is a confined state
compared with the liberation of death: 'Life is the Triumph of our
mouldering Clay; Death, of the Spirit Infinite! Divine!'

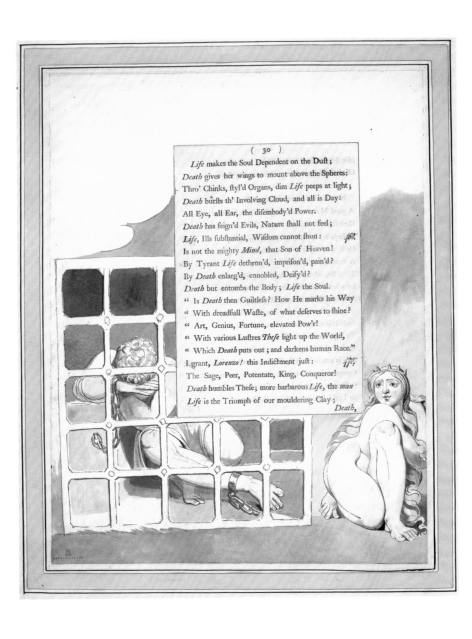

(30)

Life makes the Soul Dependent on the Duſt;
Death gives her wings to mount above the Spheres:
Thro' Chinks, ſtyl'd Organs, dim *Life* peeps at light;
Death burſts th' Involving Cloud, and all is Day:
All Eye, all Ear, the diſembody'd Power.
Death has feign'd Evils, Nature ſhall not feel;
Life, Ills ſubſtantial, Wiſdom cannot ſhun: 460.
Is not the mighty *Mind*, that Son of Heaven!
By Tyrant *Life* dethron'd, impriſon'd, pain'd?
By *Death* enlarg'd, ennobled, Deify'd?
Death but entombs the Body; *Life* the Soul.
" Is *Death* then Guiltleſs? How He marks his Way
" With dreadfull Waſte, of what deſerves to ſhine?
" Art, Genius, Fortune, elevated Pow'r!
" With various Luſtres *Theſe* light up the World,
" Which *Death* puts out; and darkens human Race."
I grant, *Lorenzo!* this Indictment juſt: 470.
The Sage, Peer, Potentate, King, Conqueror!
Death humbles Theſe; more barbarous *Life*, the *man*
Life is the Triumph of our mouldering Clay;
 Death,

Illustrations to Edward Young's *Night Thoughts*, 1796–97
Night V, p.31 'Sink into Slaves; and sell for present Hire'
Pen and watercolour
420 x 325mm (approx) I BM 1929-0713-94r

Young compares again the freedom of heaven with the confinement
of life in this world. Man is susceptible to earthly power 'barr'd by
Laws divine and human', symbolised by the manacles and evil jailors
who confine him.

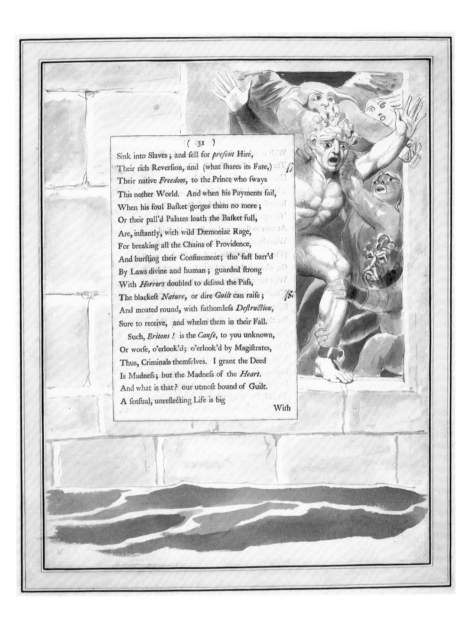

(31)

Sink into Slaves; and fell for *prefent* Hire,
Their rich Reverfion, and (what fhares its Fate,)
Their native *Freedom*, to the Prince who fways
This nether World. And when his Payments fail,
When his foul Bafket gorges them no more;
Or their pall'd Palates loath the Bafket full,
Are, inftantly, with wild Dæmoniac Rage,
For breaking all the Chains of Providence,
And burfting their Confinement; tho' faft barr'd
By Laws divine and human; guarded ftrong
With *Horrors* doubled to defend the Pafs,
The blackeft *Nature*, or dire *Guilt* can raife;
And moated round, with fathomlefs *Deftruction*,
Sure to receive, and whelm them in their Fall.

Such, *Britons !* is the *Caufe*, to you unknown,
Or worfe, o'erlook'd; o'erlook'd by Magiftrates,
Thus, Criminals themfelves. I grant the Deed
Is Madnefs; but the Madnefs of the *Heart*.
And what is that? our utmoft bound of Guilt.
A fenfual, unreflecting Life is big

With

Illustrations to Edward Young's *Night Thoughts*, 1796—97
Night VII, p.40 'Why not the Dragon's
subterranean Den for Man to howl in?'
Pen and watercolour
420 x 325mm (approx) I BM 1929-0713-157v

The non-believer mentally confined in terror at the approach of
'Death's inexorable Hand'.

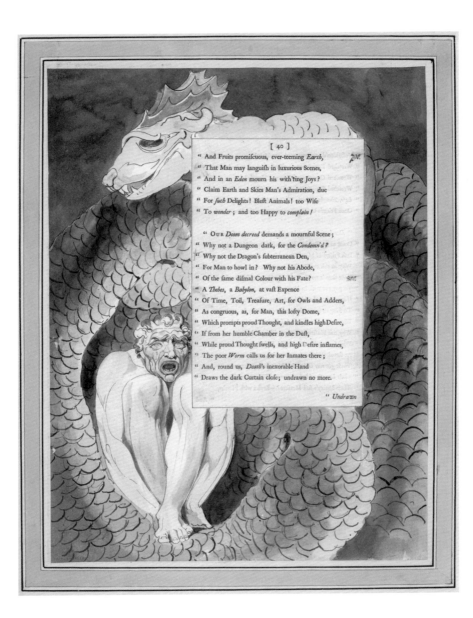

[40]

" And Fruits promiſcuous, ever-teeming *Earth*,

" That Man may languiſh in luxurious Scenes,

" And in an *Eden* mourn his with'ring Joys?

" Claim Earth and Skies Man's Admiration, due

" For *ſuch* Delights! Bleſt Animals! too Wiſe

" To *wonder* ; and too Happy to *complain!*

" OUR *Doom decreed* demands a mournful Scene ;

" Why not a Dungeon dark, for the *Condemn'd?*

" Why not the Dragon's ſubterranean Den,

" For Man to howl in? Why not his Abode,

" Of the ſame diſmal Colour with his Fate?

" A *Thebes*, a *Babylon*, at vaſt Expence

" Of Time, Toil, Treaſure, Art, for Owls and Adders,

" As congruous, as, for Man, this lofty Dome,

" Which prompts proud Thought, and kindles high Deſire,

" If from her humble Chamber in the Duſt,

" While proud Thought ſwells, and high Deſire inflames,

" The poor *Worm* calls us for her Inmates there ;

" And, round us, *Death*'s inexorable Hand

" Draws the dark Curtain cloſe; undrawn no more.

" *Undrawn*

Illustrations to Edward Young's *Night Thoughts*, 1796–97
Night VII, p.9 'Boasters of Liberty, Fast-bound in Chains'
Pen and watercolour
420 x 325mm (approx) I BM 1929-0713-167r

An attack on the frivolous pursuit of pleasure, and the delusions it
brings. Hence the figure who boasts of selfish pleasure as liberty is
shown by Blake to be in reality manacled like a slave.

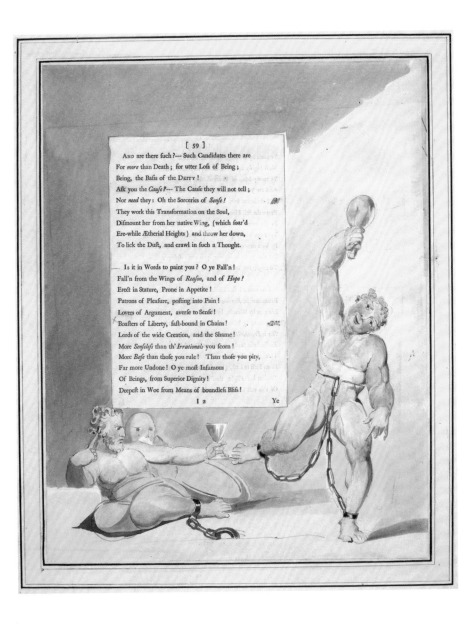

[59]

AND are there such?--- Such Candidates there are
For *more* than Death; for utter Lofs of Being;
Being, the Bafis of the DEITY!
Afk you the *Caufe?*--- The Caufe they will not tell;
Nor *need* they: Oh the Sorceries of *Senfe!*
They work this Transformation on the Soul,
Difmount her from her native Wing, (which foar'd
Ere-while Ætherial Heights) and throw her down,
To lick the Duft, and crawl in fuch a Thought.

--- Is it in Words to paint you? O ye Fall'n!
Fall'n from the Wings of *Reafon,* and of *Hope!*
Erect in Stature, Prone in Appetite!
Patrons of Pleafure, pofting into Pain!
Lovers of Argument, averfe to Senfe!
Boafters of Liberty, faft-bound in Chains!
Lords of the wide Creation, and the Shame!
More *Senfelefs* than th' *Irrationals* you fcorn!
More *Bafe* than thofe you rule! Than thofe you pity,
Far more Undone! O ye moft Infamous
Of Beings, from Superior Dignity!
Deepeft in Woe from Means of boundlefs Blifs!

I 2 Ye

Illustrations to Edward Young's *Night Thoughts*, 1796—97
Night VIII, titlepage,
Virtue's Apology: or the Man of the World Answer'd
Pen and watercolour
420 x 325mm (approx) | BM 1929-0713-174r

A brilliant image of the powers of the world who rule the mind of 'The
Man of the World', whose perceptions are confined by materialism.
These powers are derived from the Biblical Book of Revelation but
applied to the modern world. A cardinal, bishop, pope, warrior, and
judge are all shown as heads of the Great Beast of Revelation, ridden
by the Whore of Babylon, an image that goes back to Lutheran carica-
ture of Catholicism in the sixteenth-century German Reformation.

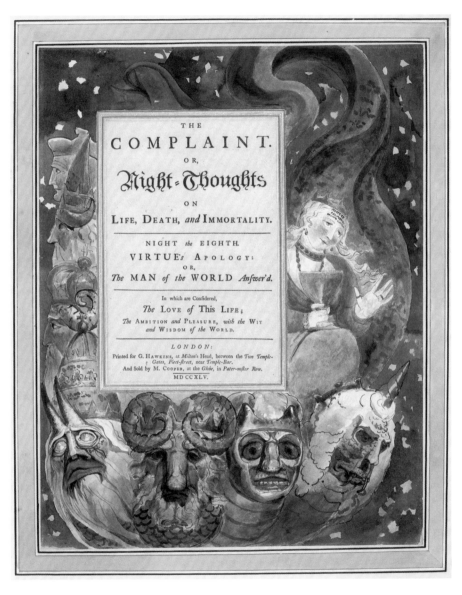

THE

COMPLAINT.

OR,

Night-Thoughts

ON

LIFE, DEATH, and IMMORTALITY.

NIGHT the EIGHTH.

VIRTUE's APOLOGY:

OR,

The MAN of the WORLD Answer'd.

In which are Considered,

The LOVE of This LIFE;

The AMBITION and PLEASURE, with the WIT
and WISDOM of the WORLD.

LONDON:

Printed for G. HAWKINS, at Milton's Head, between the Two Temple-
, Gates, Fleet-street, near Temple-Bar.
And Sold by M. COOPER, at the Globe, in Pater-noster Row.

MDCCXLV.

Illustrations to Edward Young's *Night Thoughts*, 1796—97
Night IX, p.15 'The Foe of God and Man'
Pen and watercolour
420 x 325mm (approx) | BM 1929-0713-218r

Night IX is the last book of *Night Thoughts*, 'The Consolation'. It tells of
the ultimate triumph of the Christian revelation. Here Satan receives
his final punishment. He 'Receives his Sentence, and begins his Hell',
manacled and confined for eternity.

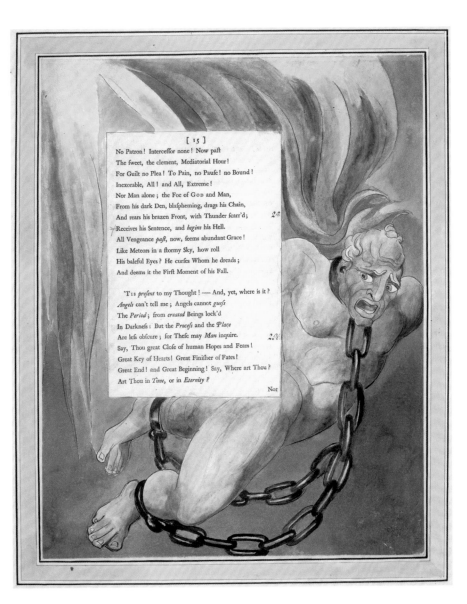

[15]

No Patron! Interceffor none! Now paſt
The ſweet, the clement, Mediatorial Hour!
For Guilt no Plea! To Pain, no Pauſe! no Bound!
Inexorable, All! and All, Extreme!
Nor Man alone; the Foe of GOD and Man,
From his dark Den, blaſpheming, drags his Chain,
And rears his brazen Front, with Thunder ſcarr'd;
Receives his Sentence, and *begins* his Hell.
All Vengeance *paſt*, now, ſeems abundant Grace!
Like Meteors in a ſtormy Sky, how roll
His baleful Eyes? He curſes Whom he dreads;
And deems it the Firſt Moment of his Fall.

'TIS *preſent* to my Thought! ---- And, yet, where is it?
Angels can't tell me; Angels cannot *gueſs*
The *Period*; from *created* Beings lock'd
In Darkneſs: But the *Proceſs* and the *Place*
Are leſs obſcure; for Theſe may *Man* inquire.
Say, Thou great Cloſe of human Hopes and Fears!
Great Key of Hearts! Great Finiſher of Fates!
Great End! and Great Beginning! Say, Where art Thou?
Art Thou in *Time*, or in *Eternity?*

Nor

Illustrations to Edward Young's *Night Thoughts*, 1796–97
Night IX, p.52 'The Soul of Man was made to walk the Skies'
Pen and watercolour
420 x 325mm (approx) | BM 1929-0713-236v

The consolation of the Christian vision is that ultimately the soul will free itself from the prison of the body. The soul 'disincumber'd from her Chains, the Ties / Of Toys terrestrial, she can rove at large'.

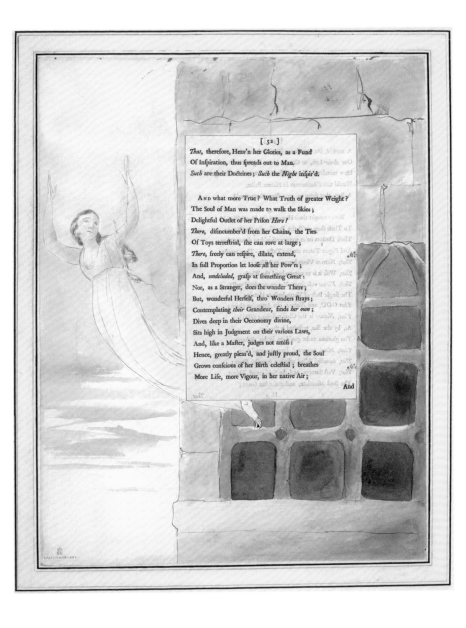

[52]

That, therefore, Heav'n her Glories, as a Fund
Of Inspiration, thus spreads out to Man.
Such are their Doctrines; *Such the Night* infpir'd.

AND what more True? What Truth of greater Weight?
The Soul of Man was made to walk the Skies;
Delightful Outlet of her Prifon *Here!*
There, difincumber'd from her Chains, the Ties
Of Toys terreftrial, fhe can rove at large;
There, freely can refpire, dilate, extend,
In full Proportion let loofe all her Pow'rs;
And, *undeluded*, grafp at fomething Great:
Nor, as a Stranger, does fhe wander There;
But, wonderful Herfelf, thro' Wonders ftrays;
Contemplating *their* Grandeur, finds *her own*;
Dives deep in their Oeconomy divine,
Sits high in Judgment on their various Laws,
And, like a Mafter, judges not amifs:
Hence, greatly pleas'd, and juftly proud, the Soul
Grows confcious of her Birth celeftial; breathes
More Life, more Vigour, in her native Air;

And

The Resurrection of the Dead
alternative design for a titlepage
to Robert Blair's *The Grave*, 1806
Pen and watercolour
425 x 310mm I BM 1856-0712-208

This drawing, which follows the rejection of Blake's engraving of his
own designs for *The Grave* by the publisher Cromek, may have been
an intended titlepage for a collection of his rejected watercolours.
The theme of the watercolour, like that of *The Grave* itself, is the ulti-
mate Christian triumph beyond the grave. The male figure on the
right has, like Orc in *America*, broken the chains that hold him to the
earth, while his son next to him is still captive.

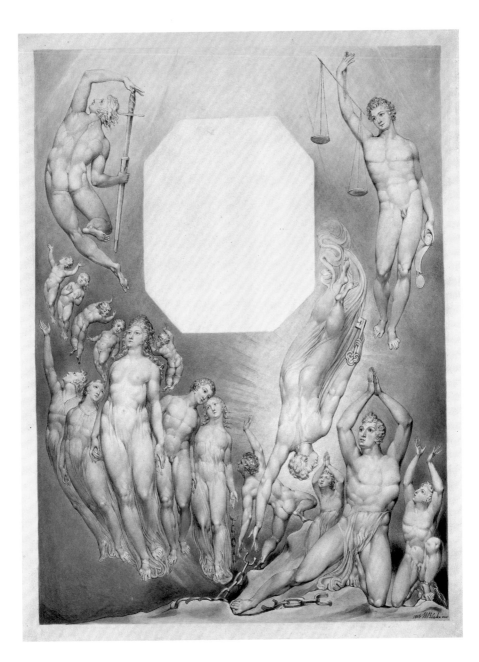

Design for the Dedication to Blair's *The Grave*,
Inscribed by Blake: *To the Queen*, 1807
Pen and watercolour
302 x 238mm | BM 1894-0612-14

In this beautiful design for the Dedication of the volume to the Queen,
which Blake wrote himself, the soul with a key in her hand, leaving
the body beneath, rises up to the golden Door of Death 'that Mortal
Eyes cannot behold'. The poem was printed in the book but not
the design.

NATIONAL LIBERATION
ALBION

Blake's last two prophetic books, *Milton, a Poem* and *Jerusalem,* were both concerned with national as well as personal redemption, embodied in the figure of Albion who is both a universal man and Britain, now in a bad way. The former tells of the struggle of poetry embodied by John Milton, Blake's flawed mentor, and Blake's own struggles to redeem the national soul, while the latter tells the story of Albion in his divisions, and his longed-for redemption in the book's final vision. Albion's division embodies a conflict of his own faculties, his separation from his emanation Jerusalem, and the alienation of his children, the people of Britain. He appears until the final vision as an agonised figure, at war with himself and others.

Preface
Milton, a Poem, Copy A, 1804–10
Relief etching and watercolour
148 x 105mm I BM 1859-0625-2

Though the poem 'And did these feet in ancient time' has become an alternative national anthem under the name 'Jerusalem', it is in fact from *Milton, a Poem* and the plate was discarded by Blake after printing two copies. Even so it expresses in its purest form Blake's hopes for national as well as personal redemption, tying it to the legendary beginnings of Christianity in England through the story of Jesus being brought to England as a young boy by Joseph of Arimathea. Note the attack on the Greek and Roman writers as 'silly Greek & Latin slaves of the sword'; they are seen as ultimately behind the modern pursuit of war and money.

PREFACE.

The Stolen and Perverted Writings of Homer &
Ovid: of Plato & Cicero. which all Men ought to
contemn: are set up by artifice against the Sublime
of the Bible. but when the New Age is, at leisure
to Pronounce; all will be set right, & those Grand
Works of the more ancient & consciously & profes-
sedly Inspired Men, will hold their proper rank, &
the Daughters of Memory shall become the Daugh-
ters of Inspiration. Shakspeare & Milton were
both curbd by the general malady & infection from
the silly Greek & Latin slaves of the Sword.
Rouze up O Young Men of the New Age! set your
foreheads against the ignorant Hirelings! For
we have Hirelings in the Camp, the Court, & the Uni-
versity: who would if they could, for ever depress Ment-
al & prolong Corporeal War. Painters! on you I call!
Sculptors! Architects! Suffer not the fashionable Fools
to depress your powers by the prices they pretend to
give for contemptible works or the expensive adver-
tising boasts that they make of such works; believe
Christ & his Apostles that there is a Class of Men
whose whole delight is in Destroying. We do not
want either Greek or Roman Models if we are but
just & true to our own Imaginations. those Worlds
of Eternity in which we shall live for ever: in
Jesus our Lord.

And did those feet in ancient time.
Walk upon Englands mountains green:
And was the holy Lamb of God,
On Englands pleasant pastures seen!

And did the Countenance Divine.
Shine forth upon our clouded hills?
And was Jerusalem builded here.
Among these dark Satanic Mills?

Bring me my Bow of burning gold:
Bring me my Arrows of desire:
Bring me my Spear: O clouds unfold:
Bring me my Chariot of fire!

I will not cease from Mental Fight.
Nor shall my Sword sleep in my hand:
Till we have built Jerusalem,
In Englands green & pleasant Land.

Would to God that all the Lords people
were Prophets. Numbers XI.ch 29.v.

Milton tearing down Urizen with Tablets
Plate 15 from *Milton, a Poem*, Copy A, 1804–11
Relief etching with watercolour
170 x 110mm I BM 1859-0625-15

Milton is depicted as an heroic poet struggling with Urizen whose hands rest on the tablets of the Ten Commandments. This is represented as Milton's struggle with the Urizen within, signaled in the inscription 'To Annihilate the Self-hood of Deceit & False Forgiveness'.

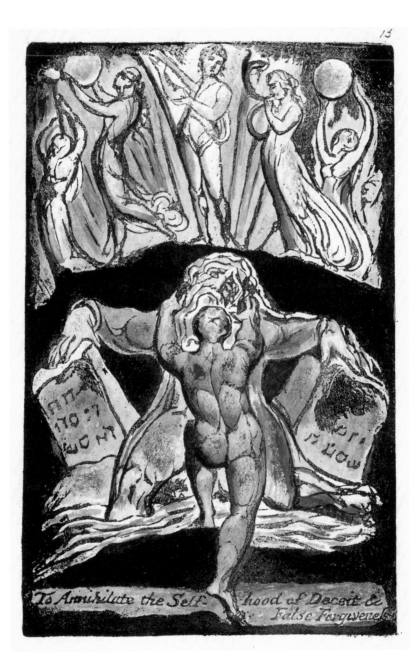

To Annihilate the Self-hood of Deceit &
False Forgiveness

Los at the forge
Plate 6 from *Jerusalem: The Emanation of The Giant Albion*,
Copy A, 1804–21
Relief etching with black added
223 x 162mm I BM 1847-0318-93-6

Los, the eternal poet and spiritual version of Blake himself in his prophetic endeavours, is shown hammering out his visions at a forge, a metaphor for the creation of *Jerusalem* itself. He is tormented by the Spectre that hovers over him 'bitterly cursing him for his friendship / to Albion, suggesting murderous thoughts against Albion'. The Spectre is a kind of false friend who urges Los to abandon his visions for conventional success, but Los resists the Spectre's pleas, looking forward to the time 'When all Albions injuries shall cease, and when we shall / Embrace him tenfold bright. Rising from his tomb in immortality'.

His Spectre driv'n by the Starry Wheels of Albions sons, black and
Opake divided from his back; he labours and he mourns!

For as his Emanation divided, his Spectre also divided
In terror of those starry wheels: and the Spectre stood over Los
Howling in pain: a blackning Shadow, blackning dark & opake
Cursing the terrible Los: bitterly cursing him for his friendship
To Albion, suggesting murderous thoughts against Albion.

Los rag'd and stamp'd the earth in his might & terrible wrath!
He stood and stamp'd the earth; then he threw down his hammer in rage &
in fury: then he sat down and wept, terrified! Then arose
And chaunted his song, labouring with the tongs and hammer:
But still the Spectre divided, and still his pain increas'd!

In pain the Spectre divided: in pain of hunger and thirst:
To devour Los's Human Perfection, but when he saw that Los

Albion with weeping Daughters
Plate 19 from *Jerusalem: The Emanation of The Giant Albion*,
Copy A, 1804–21
Relief etching with black ink added
224 x 162mm I BM 1847-0318-93-19

Albion in his division lamented by his daughters, while others seek
to escape from him.

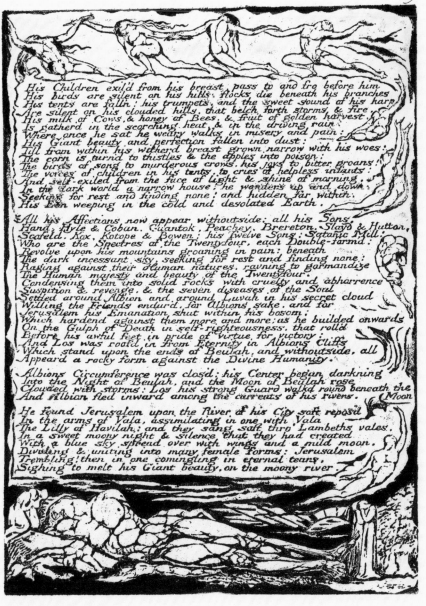

His Children exil'd from his breast, pass to and fro before him
His birds are silent on his hills, flocks die beneath his branches
His tents are falln: his trumpets, and the sweet sound of his harp
Are silent on his clouded hills, that belch forth storms & fire
His milk of Cows, & honey of Bees, & fruit of golden harvest,
Is gatherd in the scorching heat, & in the driving rain:
Where once he sat he weary walks in misery and pain:
His Giant beauty and perfection fallen into dust:
Till from within his witherd breast grown narrow with his woes:
The corn is turnd to thistles & the apples into poison:
The birds of song to murderous crows, his joys to bitter groans
The voices of children in his tents, to cries of helpless infants:
And self-exiled from the face of light & shine of morning,
In the dark world a narrow house: he wanders up and down,
Seeking for rest and finding none: and hidden far within,
His Eon weeping in the cold and desolated Earth.

All his Affections now appear withoutside: all his Sons,
Hand, Hyle & Coban. Guantok, Peachey. Brereton, Slayd & Hutton,
Scofeld. Kox, Kotope & Bowen; his Twelve Sons; Satanic Mill;
Who are the Spectres of the Twentyfour, each Double-formd:
Revolve upon his mountains groaning in pain: beneath
The dark incessant sky, seeking for rest and finding none:
Raging against their Human natures. ravning to gormandize
The Human majesty and beauty of the Twentyfour.
Condensing them into solid rocks with cruelty and abhorrence
Suspicion & revenge. & the seven diseases of the Soul
Settled around Albion and, around Luvah in his secret cloud
Willing the Friends endurd, for Albions sake, and for
Jerusalem his Emanation shut within his bosom:
Which hardend against them more and more; as he builded onwards
On the Gulph of Death in self-righteousness. that rolld
Before his awful feet in pride of virtue for victory:
And Los was roofd in from Eternity in Albions Cliffs
Which stand upon the ends of Beulah, and withoutside, all
Appeard a rocky form against the Divine Humanity.

Albions Circumference was clos'd: his Center began darkning
Into the Night of Beulah, and the Moon of Beulah rose
Clouded with storms: Los his strong Guard walkd round beneath the
And Albion fled inward among the currents of his rivers. (Moon

He found Jerusalem upon the River of his City soft reposd
In the arms of Vala, assimilating in one with Vala
The Lilly of Havilah: and they sang soft thro' Lambeths vales,
In a sweet moony night & silence that they had created
With a blue sky spread over with wings and a mild moon.
Dividing & uniting into many female Forms: Jerusalem
Trembling! then in one commingling in eternal tears,
Sighing to melt his Giant beauty, on the moony river.

Albion and the Fates
Plate 25 from *Jerusalem: The Emanation of The Giant Albion*,
Copy A, 1804–21
Relief etching with black ink added
219 x 161mm I BM 1847-0318-93-25

Albion shown with his daughters as the classical Three Fates, weaving his mortal destiny. The firmament painted on his body connects him with ancient British myths, showing him, as does the reference to the Fates, imprisoned by pagan religion.

And there was heard a great lamenting in Beulah: all the Regions
Of Beulah were moved as the tender bowels are moved: & they said:

Why did you take Vengeance O ye Sons of the mighty Albion?
Planting these Oaken Groves: Erecting these Dragon Temples
Injury the Lord heals, but Vengeance cannot be healed:
As the Sons of Albion have done to Luvah: so they have in him
Done to the Divine Lord & Saviour, who suffers with those that suffer;
For not one sparrow can suffer. & the whole Universe not suffer also,
In all its Regions, & its Father & Saviour not pity and weep
But Vengeance is the destroyer of Grace & Repentance in the bosom
Of the Injurer: in which the Divine Lamb is cruelly slain;
Descend O Lamb of God & take away the imputation of Sin
By the Creation of States & the deliverance of Individuals Evermore Amen

Thus wept they in Beulah over the Four Regions of Albion
But many doubted & despaird & imputed Sin & Righteousness
To Individuals & not to States, and these Slept in Ulro.

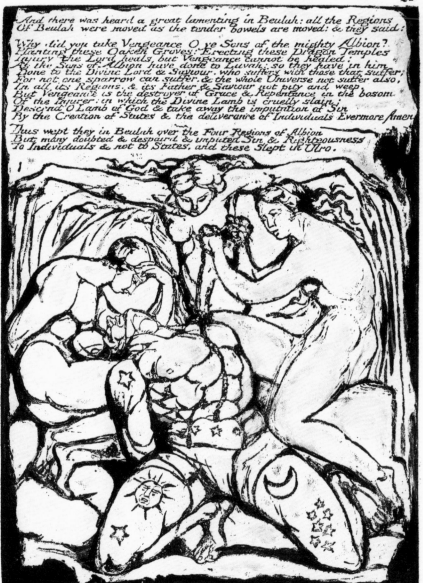

Each man is in his Spectre's power
Plate 37 (41) from *Jerusalem: The Emanation of The Giant Albion*,
Copy A, 1804–21
Relief etching, black ink and grey wash added
222 x 162mm I BM 1847-0318-93-37

Probably Albion in despair, self-enclosed in a mental prison. The text
in reverse reads:

Each Man is in His Spectre's power
Until the arrival Of that hour,
When his Humanity awake
And cast his Spectre Into the Lake.

Bath who is Legions: he is the Seventh, the physician and
The poisoner: the best and worst in Heaven and Hell:
Whose Spectre first assimulated with Luvah in Albions mountains
A triple octave he took, to reduce Jerusalem to twelve
To cast Jerusalem forth upon the wilds to Poplar & Bow:
To Malden & Canterbury in the delights of cruelty:
The Shuttles of death sing in the sky to Islington & Pancrass
Round Marybone to Tyburns River, weaving black melancholy, as a net.
And despair as meshes closely wove over the west of London.
Where mild Jerusalem sought to repose in death & be no more.
She fled to Lambeths mild Vale and hid herself beneath
The Surrey Hills where Rephaim terminates: her Sons are siezd
For victims of sacrifice; but Jerusalem cannot be found, Hid
By the Daughters of Beulah: gently snatchd away: and hid in Beulah

There is a Grain of Sand in Lambeth that Satan cannot find
Nor can his Watch Fiends find it: tis translucent & has many Angles
But he who finds it will find Oothoons palace, for within
Opening into Beulah, every angle is a lovely heaven
But should the Watch Fiends find it, they would call it Sin
And lay its Heavens & their inhabitants in blood of punishment
Here Jerusalem & Vala were hid in soft slumberous repose
Hid from the terrible East, shut up in the South & West.

The Twenty-eight trembled in Deaths dark caves, in cold despair
They kneeld around the Couch of Death in deep humiliation
And tortures of self condemnation while their Spectres raged within.
The Four Zoa's in terrible combustion clouded rage
Drinking the shuddering fears & loves of Albions Families
Destroying by selfish affections the things that they most admire
Drinking & eating, & pitying & weeping, as at a tragic scene.
The soul drinks murder & revenge, & applauds its own holiness

They saw Albion endeavouring to destroy their Emanations

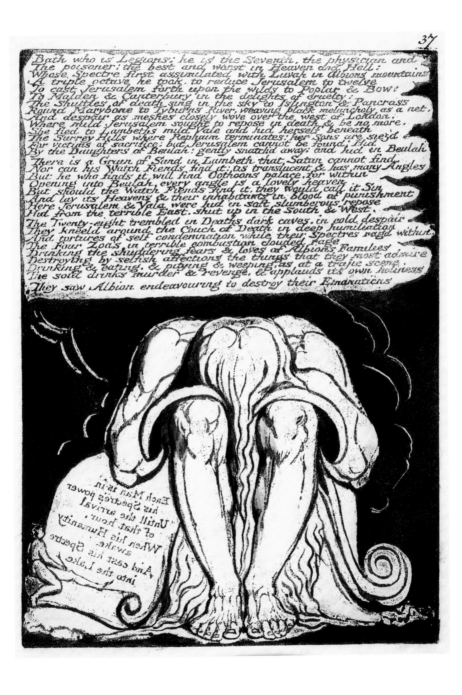

Each Man is in
his Spectres power
Untill the arrival
of that hour,
When his Humanity
awake,
And cast his Spectre
into the Lake.

Vala, Hyle and Skofeld,
Plate 51 from *Jerusalem: The Emanation of The Giant Albion,*
Copy A, 1804–21
Relief etching with black ink added
220 x 160mm I BM 1847-0318-93-51

A grim image of the powers that rule the world: Vala or nature; Hyle, the despair of unredeemed material vision; and Skofeld, or war, all of whom are aspects of Albion's psyche in the present state of the nation. Skofeld in his chains and on fire represents an anti-heroic view of war as a state of enslavement.

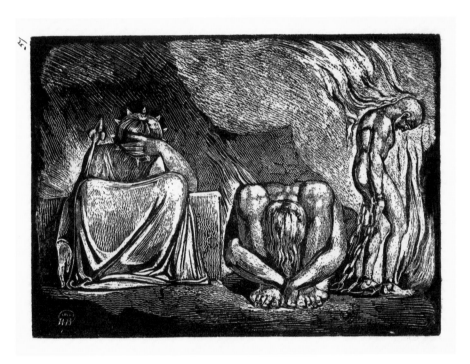

Albion before Jesus
Plate 76, from
Jerusalem: The Emanation of The Giant Albion, Copy A, 1804–21
Relief etching with black ink added
222 x 161mm I BM 1847-0318-93-76

As the frontispiece to the fourth or final book of *Jerusalem, To the Christians*, this image prefigures Albion's awakening and recognition of the Christian revelation. Albion / Britain finally understands the meaning of Jesus' sacrifice on the Cross, this time represented as the Tree of Life that grew in the Garden of Eden. The light suggests dawn rising, while Albion is illuminated by the light of Christ. Albion's pose is transformed from the agonised or self-enclosed figure of his previous representations in *Jerusalem* to a state of exultation, his arms outspread.

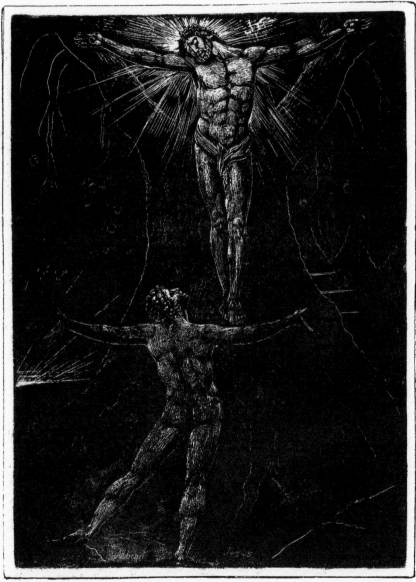

Albion rises up
Plate 95 from *Jerusalem: The Emanation of The Giant Albion,*
Copy A, 1804–21
Relief etching with black ink added
198 x 135mm I BM 1847-0318-93-95

The vision of the indefinite future when Albion shall awake from his agony of self-division occupies the last few pages of *Jerusalem.* Albion in this plate finally rises up, liberated from his slumber as 'the Breath Divine went forth over the morning hills'.

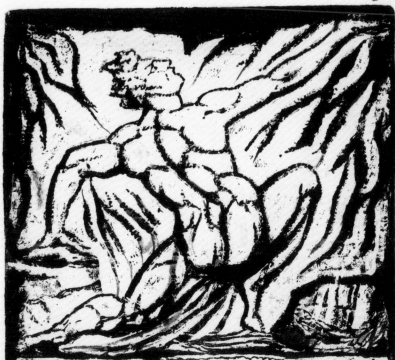

Her voice pierced Albions clay cold ear. he moved upon the Rock
The Breath Divine went forth upon the morning hills Albion mov'd
Upon the Rock. he opend his eyelids in pain; in pain he mov'd
His stony members. he saw England. Ah! shall the Dead live again

The Breath Divine went forth over the morning hills Albion rose
In anger: the wrath of God breaking bright flaming on all sides around
His awful limbs: into the Heavens he walked clothed in flames
Loud thundring, with broad flashes of flaming lightning & pillars
Of fire. speaking the Words of Eternity in Human Forms, in direful
Revolutions of Action & Passion. thro the Four Elements on all sides
Surrounding his awful Members. Thou seest the Sun in heavy clouds
Struggling to rise above the Mountains. in his burning hand
He takes his Bow, then chooses out his arrows of flaming gold
Murmuring the Bowstring breathes with ardor! clouds roll round the
Horns of the wide Bow, loud sounding winds sport on the mountain brows
Compelling Urizen to his Furrow! & Tharmas to his Sheepfold:
And Luvah to his Loom: Urthona he beheld mighty labouring at
His Anvil. in the Great Spectre Los unwearied labouring & weeping
Therefore the Sons of Eden praise Urthonas Spectre in songs
Because he kept the Divine Vision in time of trouble.

As the Sun & Moon lead forward the Visions of Heaven & Earth
England who is Brittannia enterd Albions bosom rejoicing.
Rejoicing in his indignation! adoring his wrathful rebuke.
She who adores not your frowns will only loathe your smiles

Los with globe
Plate 97 from *Jerusalem: The Emanation of The Giant Albion,*
Copy A, 1804–21
Relief etching with black ink added
208 x 150mm I BM 1847-0318-93-97

A glorious vision of the triumph of Los or prophetic poetry in Albion's
awakening to the divine. This image is a kind of counterpart of the
frontispiece to *Jerusalem* where Los as a night watchman carrying a
lamp enters into a door into the grave. Here Los is now naked and the
lamp has become the sun.

Awake! Awake Jerusalem! O lovely Emanation of Albion
Awake and overspread all Nations as in Ancient Time
For lo! the Night of Death is past and the Eternal Day
Appears upon our Hills: Awake Jerusalem, and come away

So spake the Vision of Albion & in him so spake in my hearing
The Universal Father. Then Albion stretchd his hand into Infinitude.
And took his Bow. Fourfold the Vision for bright beaming Urizen
Layd his hand on the South & took a breathing Bow of carved Gold
Luvah his hand stretchd to the East & bore a Silver Bow bright shining
Tharmas Westward a Bow of Brass pure flaming richly wrought
Urthona Northward in thick storms a Bow of Iron terrible thundering
And the Bow is a Male & Female & the Quiver of the Arrows of Love,
Are the Children of this Bow: a Bow of Mercy & Loving-kindness: laying
Open the hidden Heart in Wars of mutual Benevolence Wars of Love
And the hand of Man grasps firm between the Male & Female Loves
And he Clothed himself in Bow & Arrows in awful state Fourfold
In the midst of his Twenty-eight Cities each with his Bow breathing

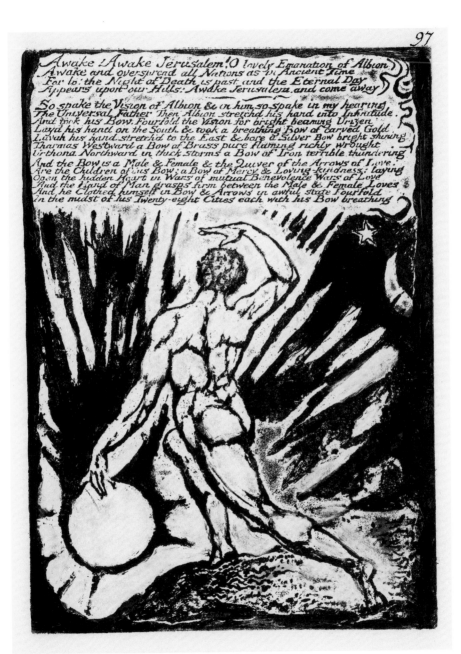

Reconciliation
Plate 99: tailpiece, from
Jerusalem: The Emanation of The Giant Albion, Copy A, 1804–21
Relief etching with black ink added
224 x 152mm I BM 1847-0318-93-99

In this penultimate plate of *Jerusalem* the identity of the figures is uncertain, but their role as opposites reconciled is clear. In the final vision of redemption all disunities – sexual, material, emotional and intellectual – are made one.

All Human Forms identified even Tree Metal Earth & Stone. all
Human Forms identified. living going forth & returning wearied
Into the Planetary lives of Years Months Days & Hours reposing
And then Awaking into his Bosom in the Life of Immortality.
And I heard the Name of their Emanations they are named Jerusalem

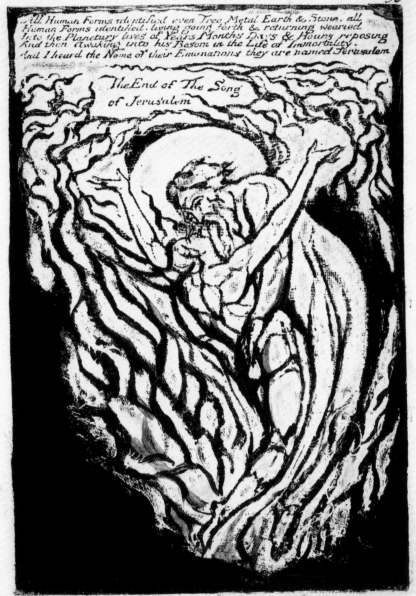

The End of The Song
of Jerusalem

WILLIAM BLAKE BIOGRAPHY

William Blake was born on the 28th November 1757 at 28 Broad Street, Soho in London, where his father was a hosier. He was apprenticed in 1769–70 to the engraver James Basire, who employed him to make drawings and engravings for several publications. In 1779 he was admitted to the Royal Academy as an engraver. There he became friendly with the sculptor John Flaxman and the painter Thomas Stothard. He began to make a living as a copy engraver, but he also exhibited watercolours at the Royal Academy and in 1783 he published his first volume of poetry, *Poetical Sketches*.

The tragedy of his younger brother Robert's death seems to have propelled him to devise a wholly new method of printing that allowed him to integrate text and design on one copper plate. This he called 'Illuminated-printing' and it was used by him to produce and publish series of completely original prophetic books, a number of which are represented in this exhibition. They tell, in biblical language but with his own invented personifications, of the spiritual history of mankind and its hoped for redemption.

After the completion of the first cycle of prophetic books in 1795 he returned to illustrating the writings of other poets, while making a living as an engraver. In 1799 he devised another original medium, painting in what he called 'Fresco', which he used for a series of 50 Biblical subjects for his patron Thomas Butts, followed by a longer series of Biblical watercolours. He spent three years from 1800–03 out of London in Felpham, Sussex, working unhappily for the minor poet William Hayley. Until about 1820 he was occupied with his last and most detailed prophecies, *Milton, a Poem* and *Jerusalem*, while working on watercolour illustrations to Milton and other poets.

His final years from 1820–27 were dominated by his friendship with the young landscape painter John Linnell who commissioned from him major series of watercolours to *The Book of Job* and to Dante's *Divine Comedy* which remained unfinished at his death on 12 August 1827.

GLOSSARY

ALBION The central figure of the book *Jerusalem*, Albion is both everyman and Britain, trapped in a materialistic state until his redemption at the end of the book. Albion's Sons are the men of Britain and the Daughters of Albion are the women of Britain.

BROMION The brutal husband and slave owner who rapes Oothoon in *Visions of the Daughters of Albion*.

EMANATION The female counterpart of a male figure; hence Enitharmon is Los's emanation, as Jerusalem is Albion's.

ENITHARMON The emanation of Los, the eternal prophet-poet, whom she encourages to make pleasing rather than prophetic works.

EXPERIENCE The fallen state of humanity in the material world, which is entered from Innocence at the point of adolescence. Though painful and divided it is a necessary stage on the way to redemption.

FOUR ZOAS The four aspects that make up the whole person, and which are at war with each other in the person of Albion: Los / Urthona (imagination), Luvah / Orc (revolutionary energy), Tharmas (body or senses), Urizen (reason / legalism).

INNOCENCE The state of childhood, the uncomplicated sense of joy in the divine, which must confront the world of Experience.

JERUSALEM Albion's emanation and the object of his quest for unity. She is both city (cf.Bunyan's *Pilgrim's Progress*) and woman, also liberty.

LOS One of the Four Zoas and the eternal poet and spiritual counterpart of Blake himself in his struggle to give form to the forces that govern humanity. He is also imagination at war with, yet also the creator of the form of, Urizen.

OOTHOON The female heroine of *Visons of the Daughters of Albion,* she represents the discontent of the women of Britain seeking freedom but thwarted by society.

ORC Revolutionary energy whose breaking of his chains presages the outbreak of the American and French Revolutions by challenging the old order in the form of Urizen.

THARMAS See Four Zoas.

THEOTORMON The 'god-tormented' lover of Oothoon, unable to free her from Bromion in *Visions of the Daughters of Albion*.

URIZEN One of the Four Zoas, he represents the reasoning part of the mind, but he has a role as the creator of the material world or Jehovah. He also appears as a Jupiter-figure and representative of counter-revolutionary tyranny.

VALA The seductive goddess of nature, sometimes depicted as a false alternative to Jerusalem.

MIND-FORG'D MANACLES

WILLIAM BLAKE AND SLAVERY